FOOD PLAY

A collection of pictures by

SAXTON FREYMANN

CHRONICLE BOOKS
SAN FRANCISCO

First published in the United States in 2006 by Chronicle Books LLC.

Library of Congress Cataloging-in-Publication Data available.

ISBN-10: 0-8118-5705-0
ISBN-13: 978-0-8118-5705-5

Manufactured in Singapore.

All food sculptures are made entirely of fruits and vegetables.
Design and illustration by Saxton Freymann.
Photography by Nimkin/Parrinello and Saxton Freymann.

Distributed in Canada by Raincoast Books
9050 Shaughnessy Street
Vancouver, British Columbia V6P 6E5

10 9 8 7 6 5 4 3 2 1

Chronicle Books LLC
85 Second Street
San Francisco, California 94105

www.chroniclebooks.com

For my wonderful family,
who ate most of the contents of this book.

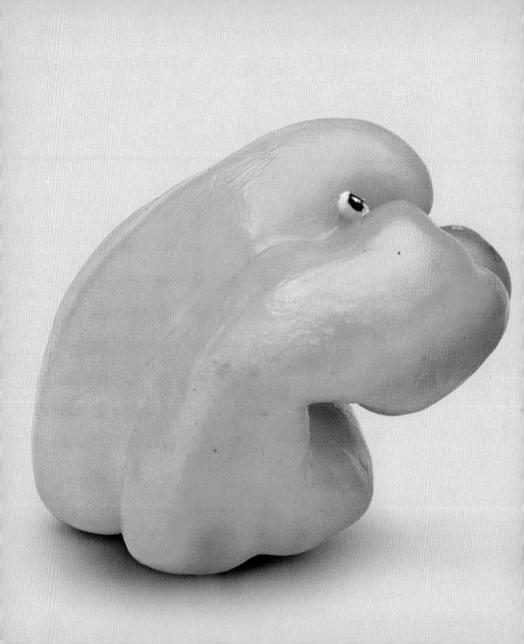

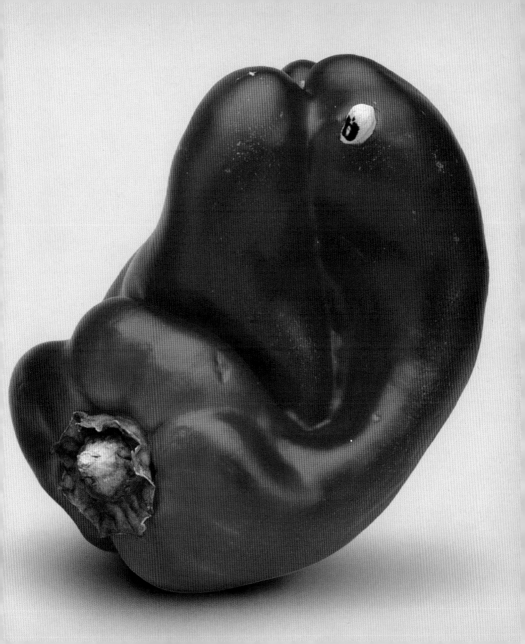

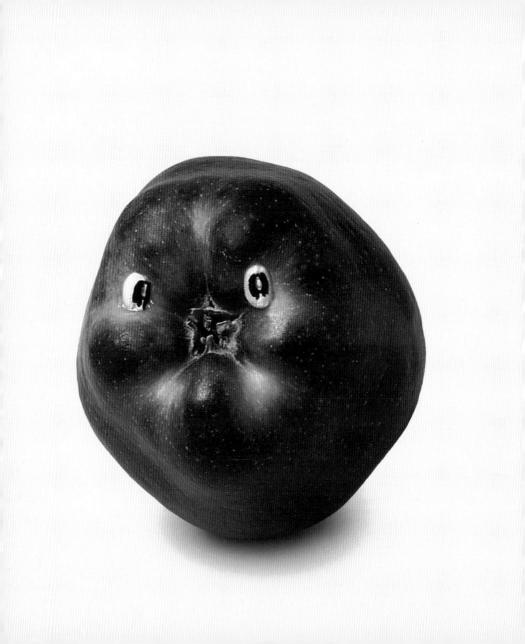

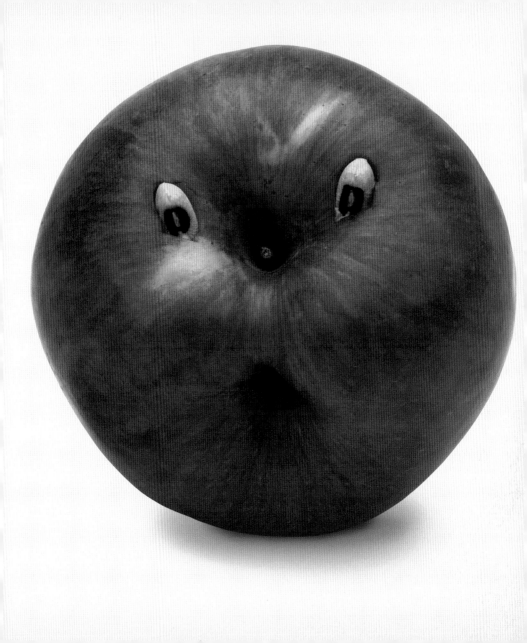

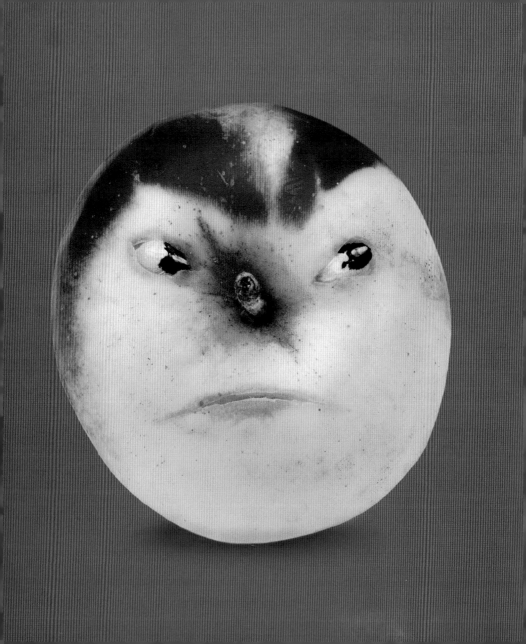

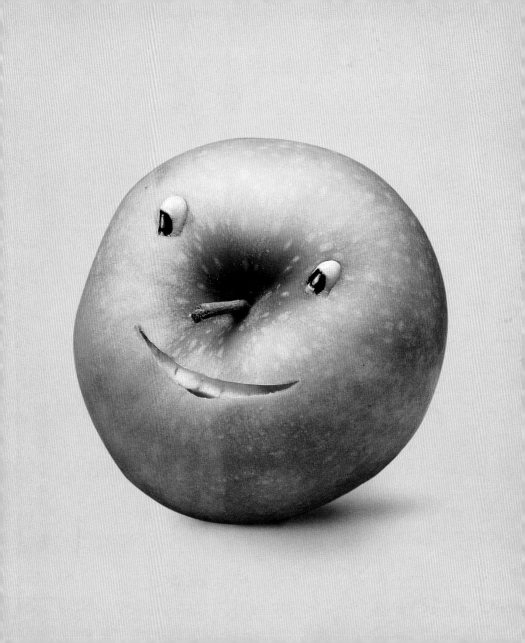

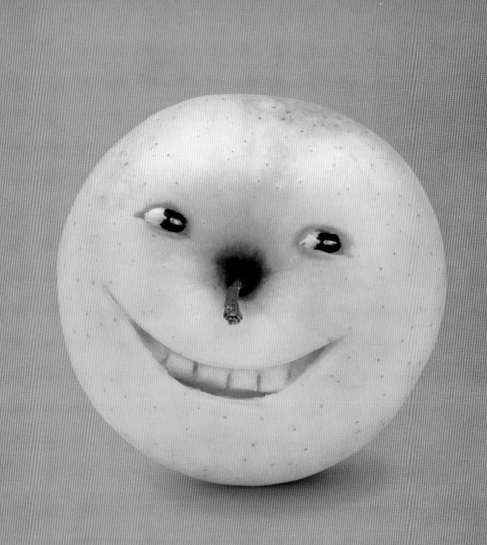

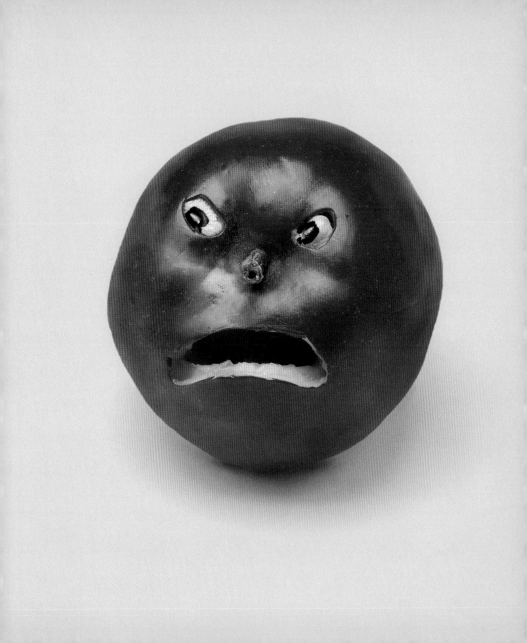

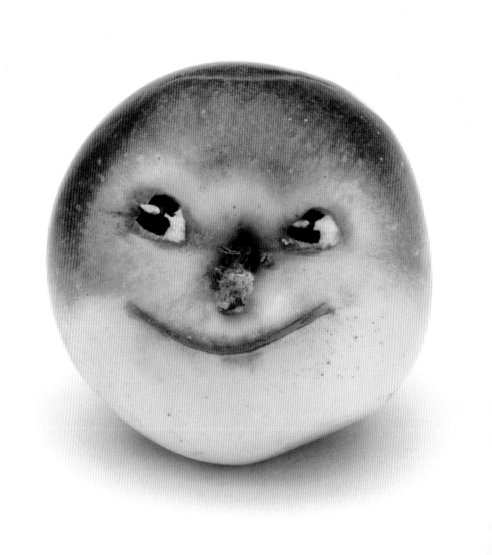

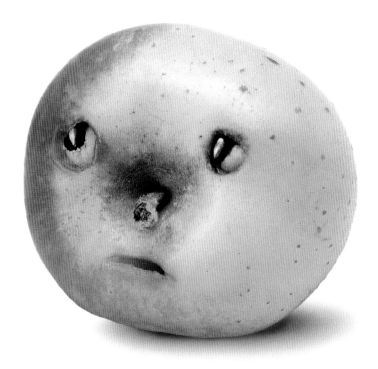

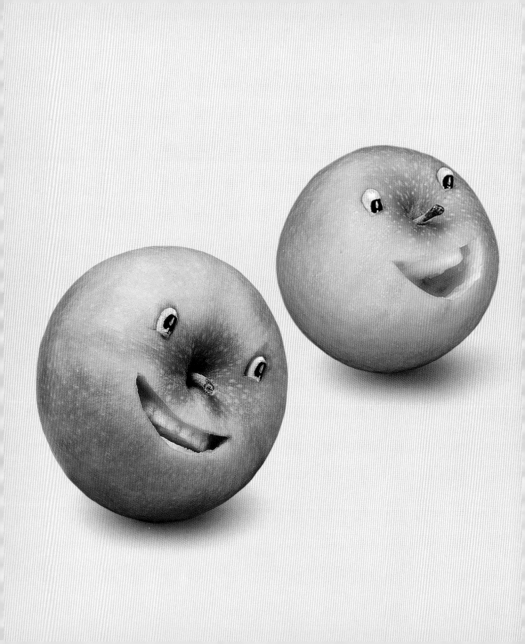

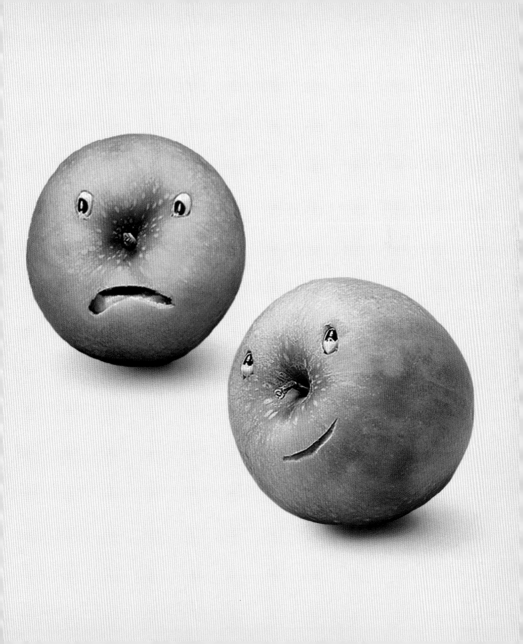

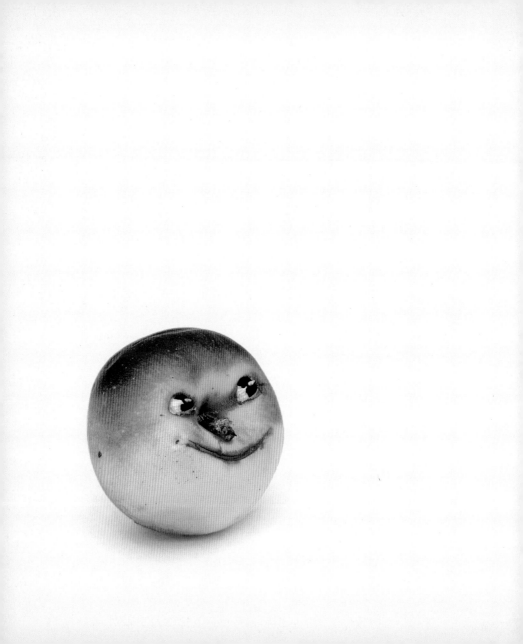

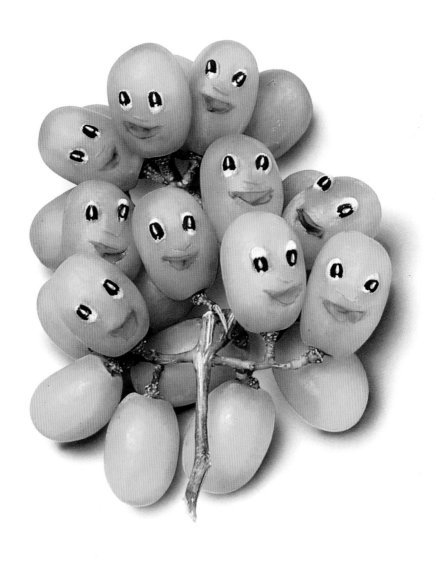

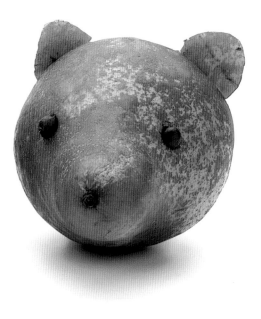

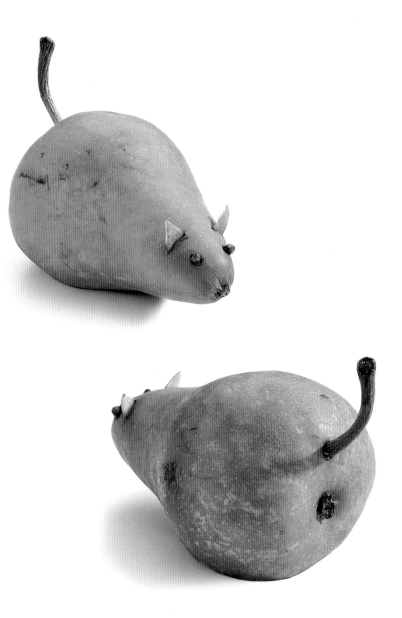

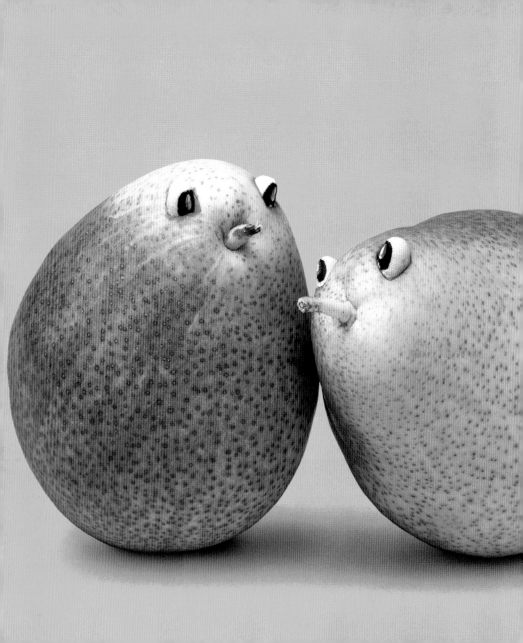

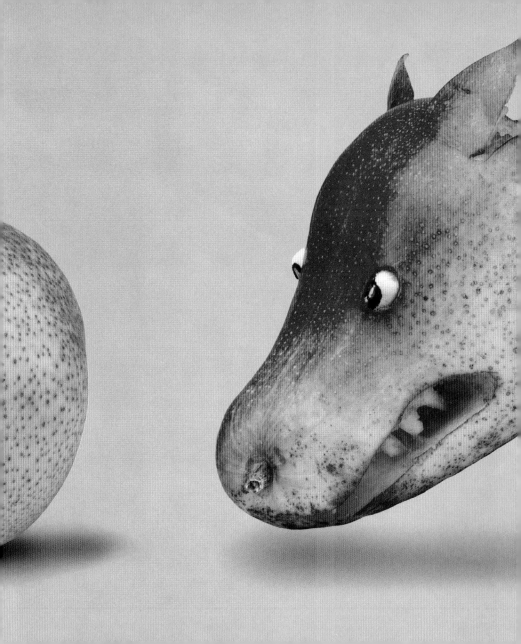

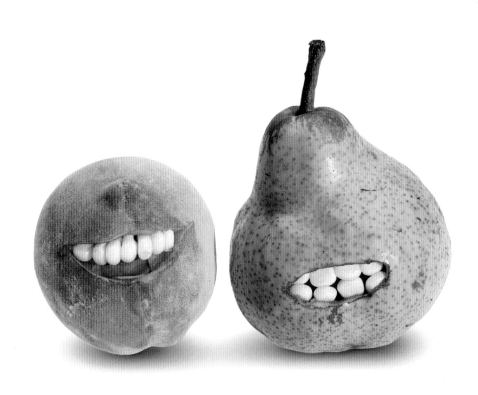

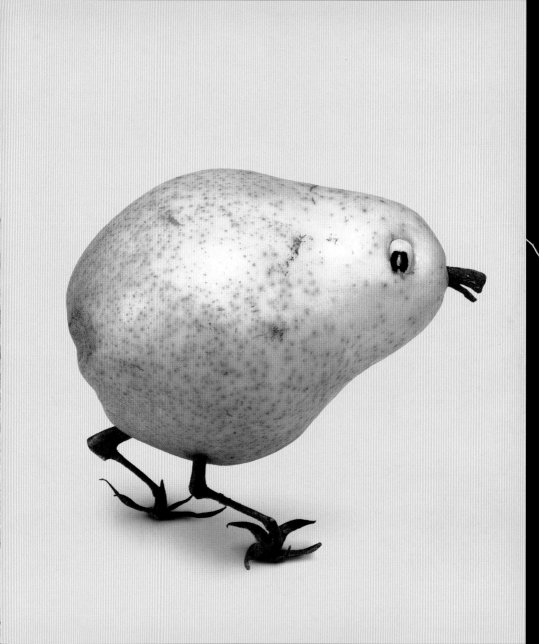

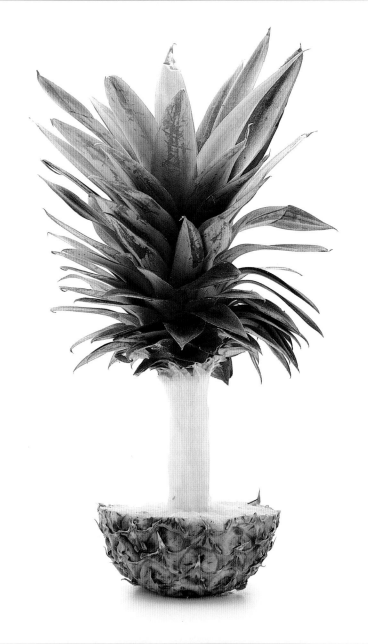

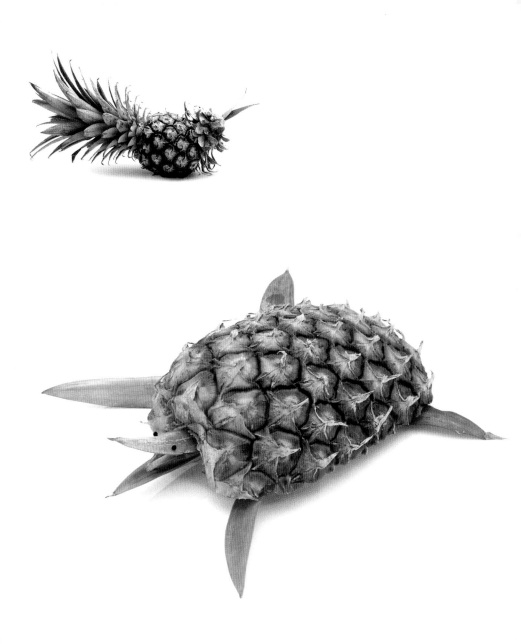

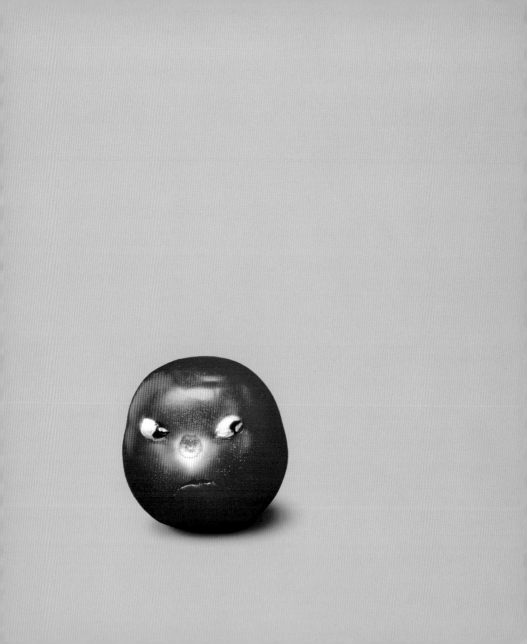

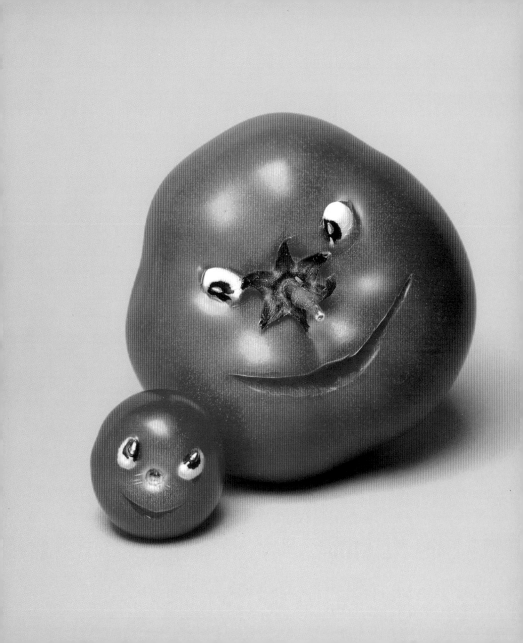

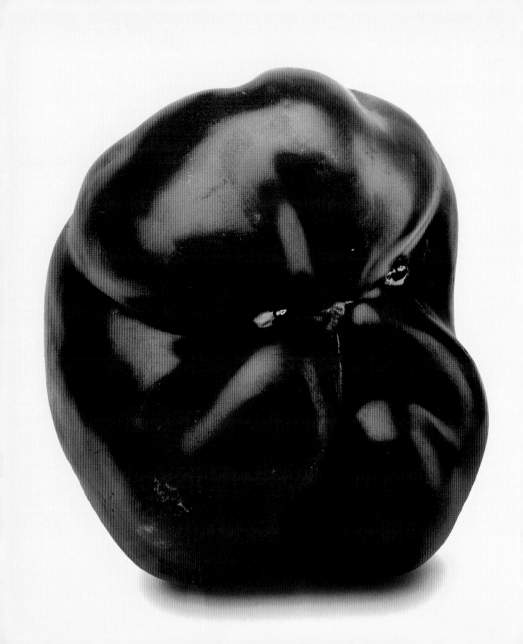

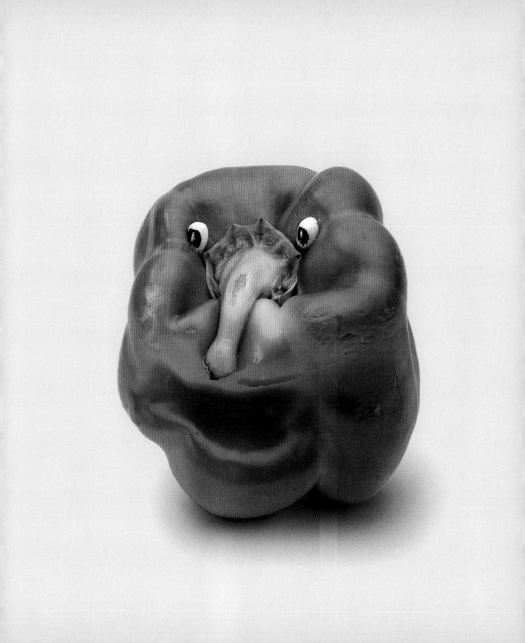

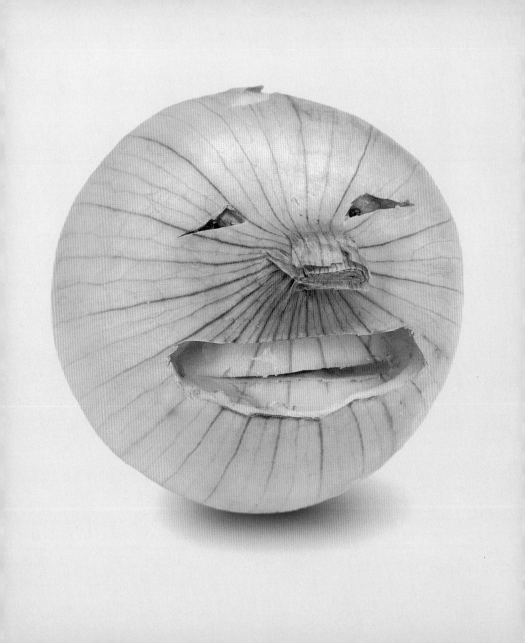

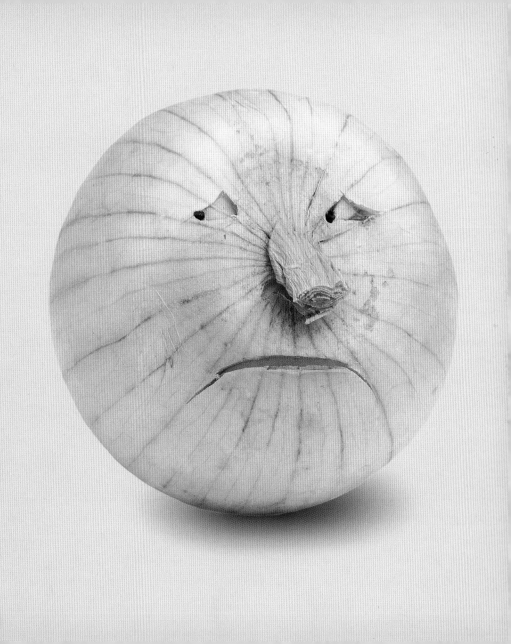

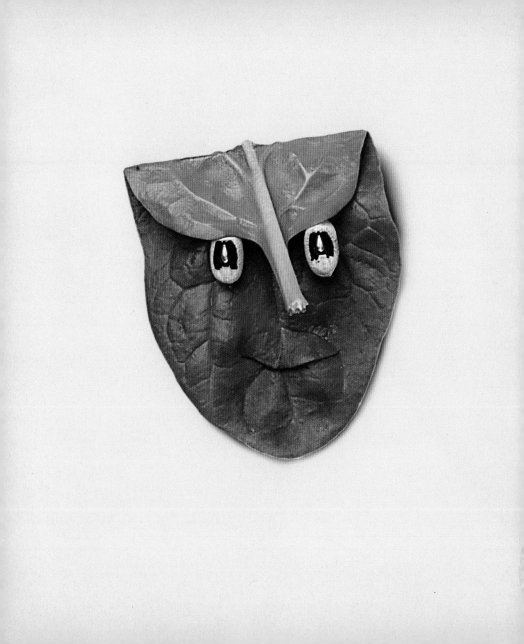

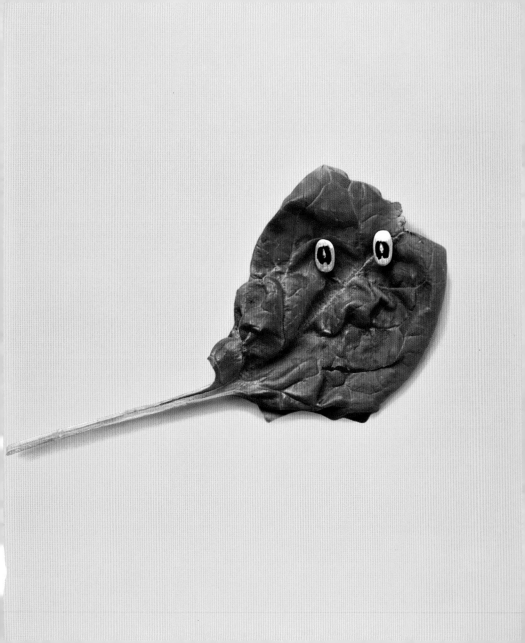

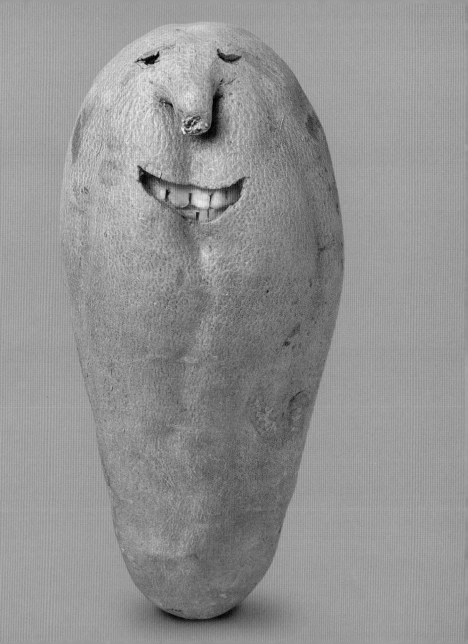

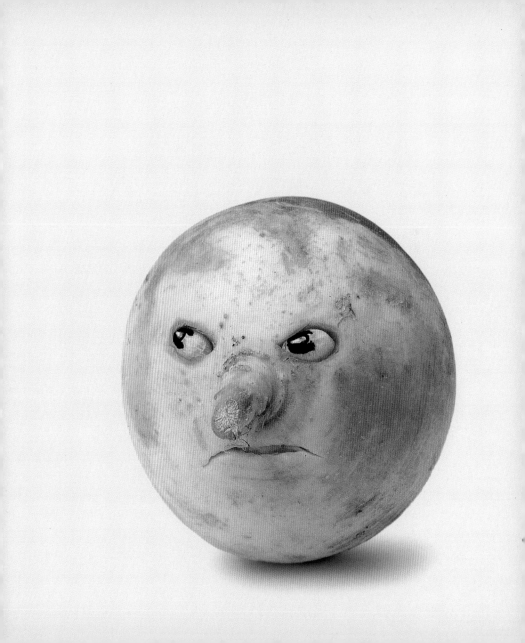

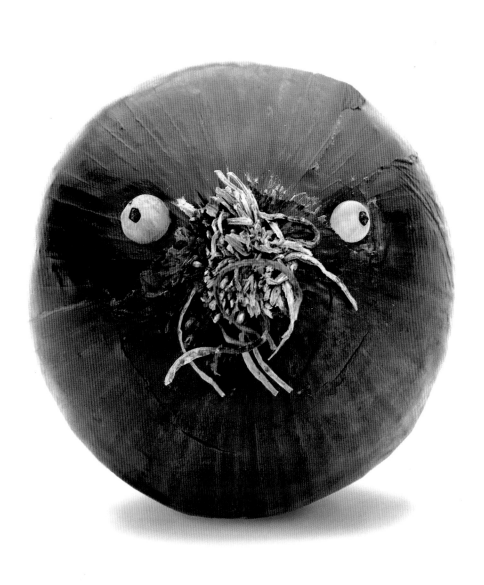

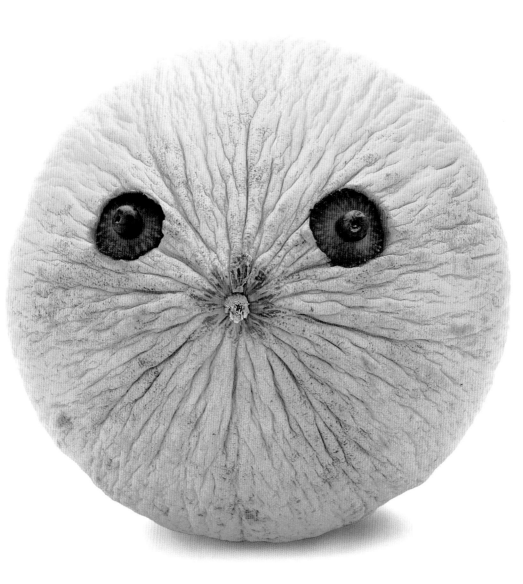

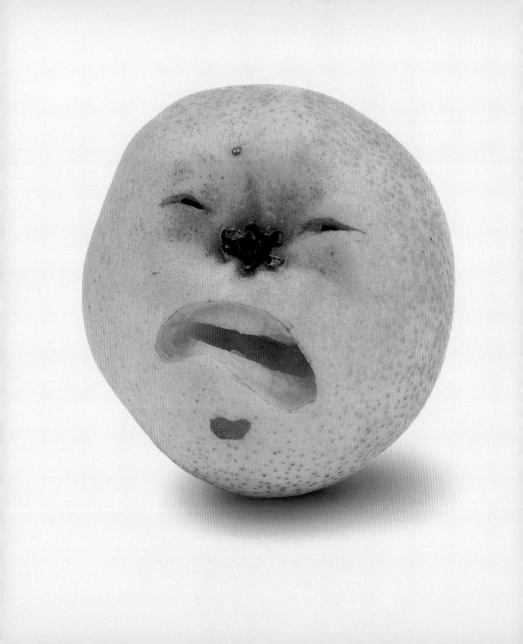

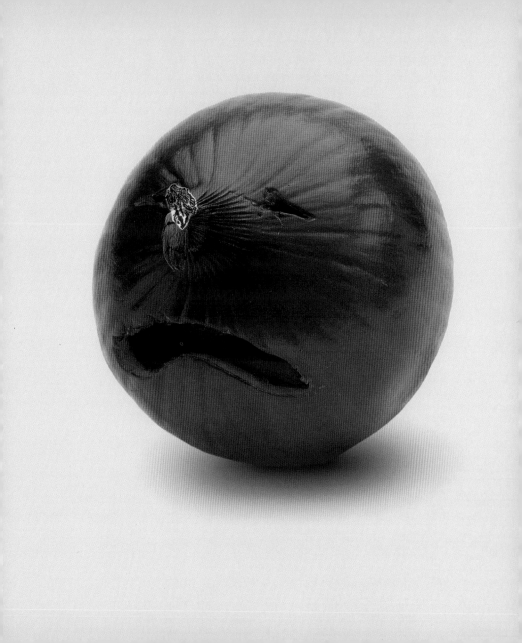

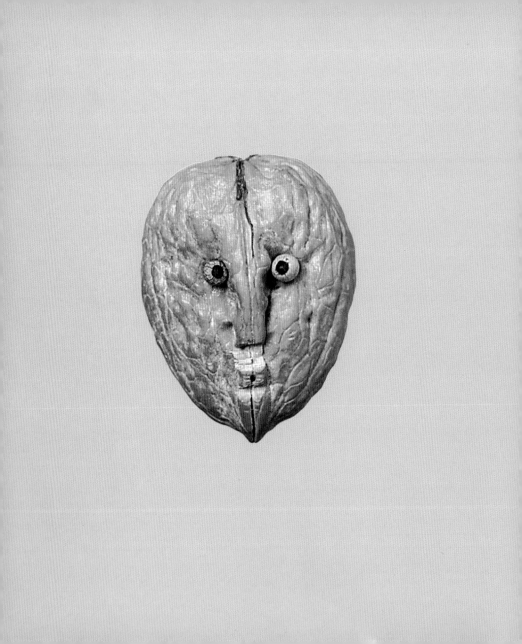

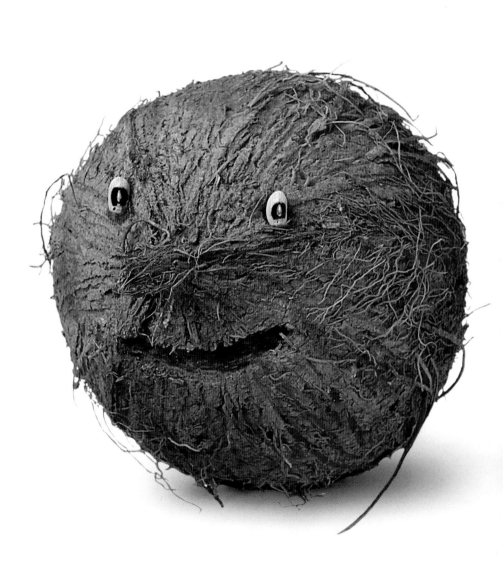

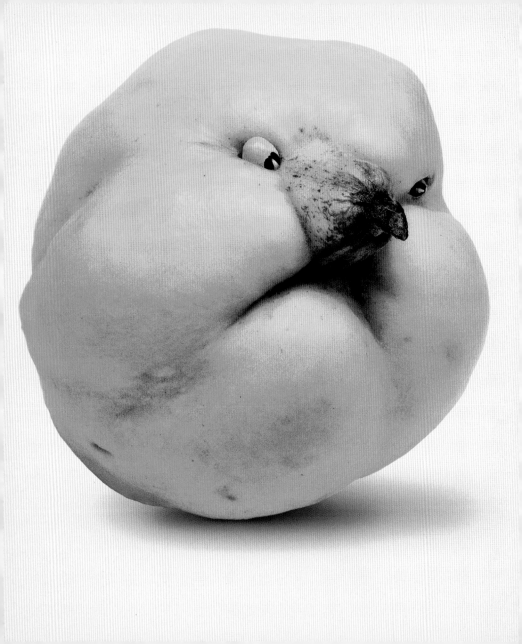

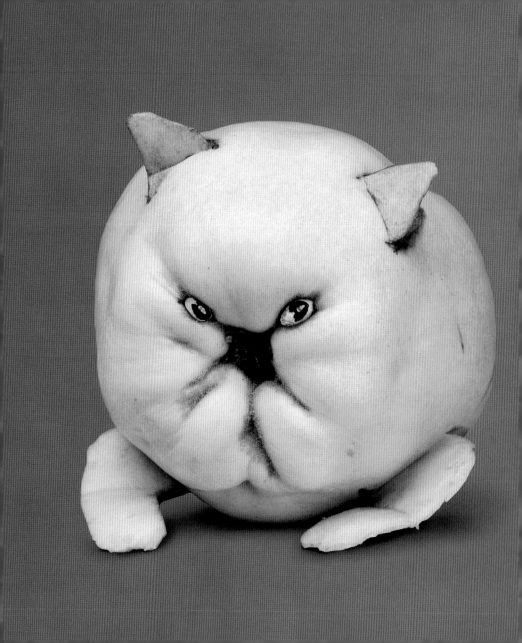

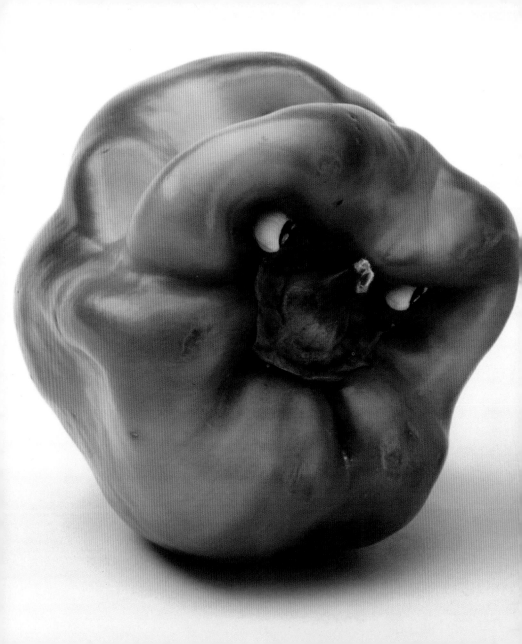

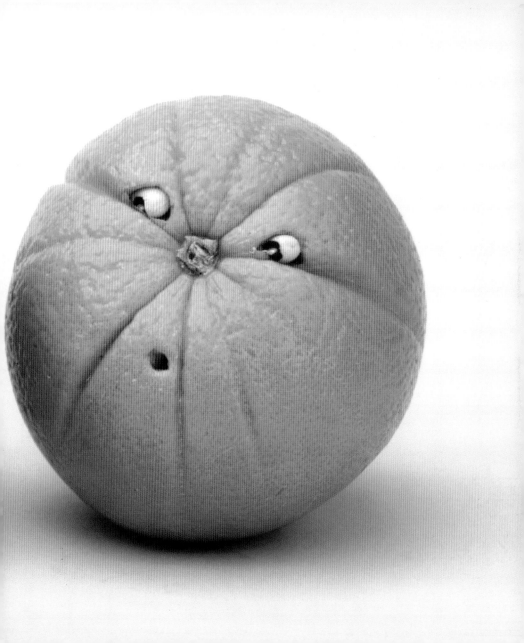

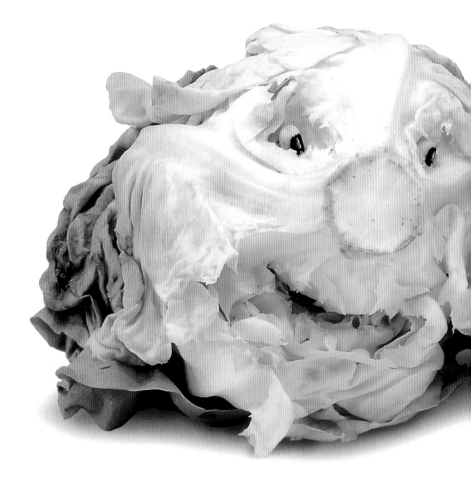

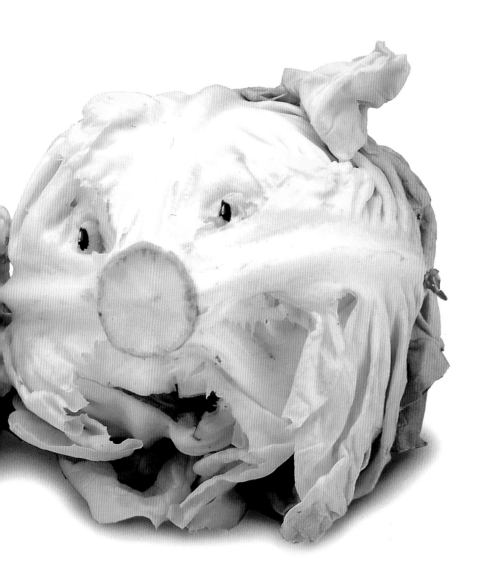

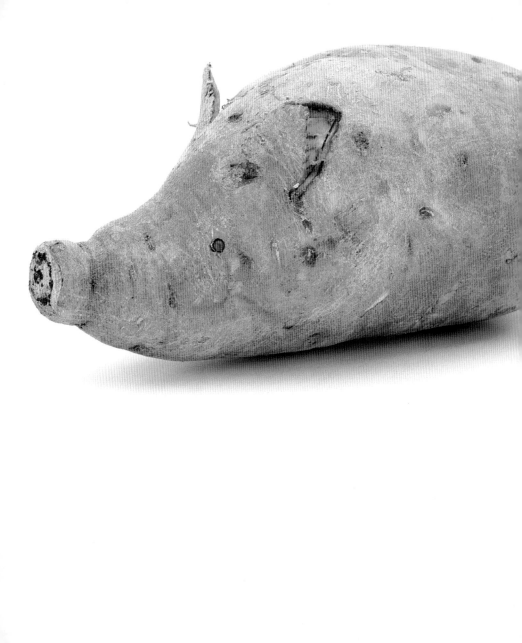

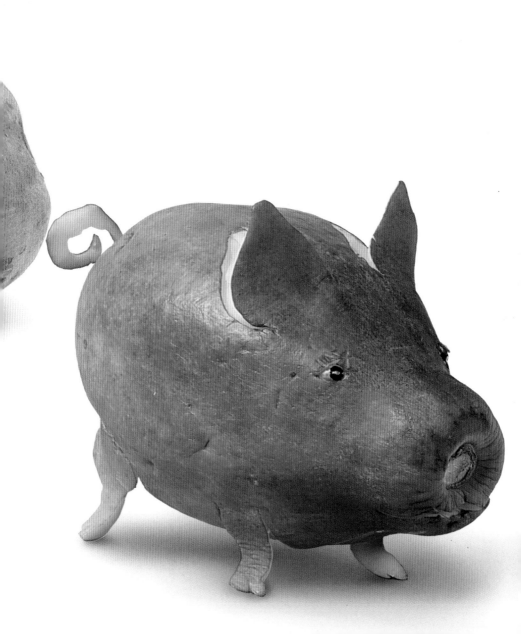

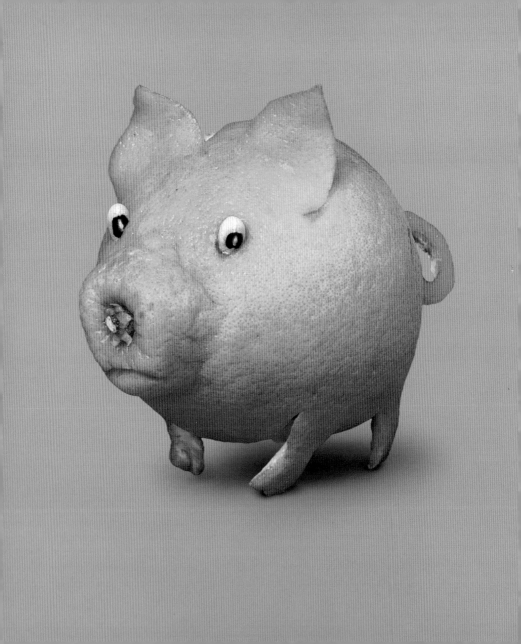

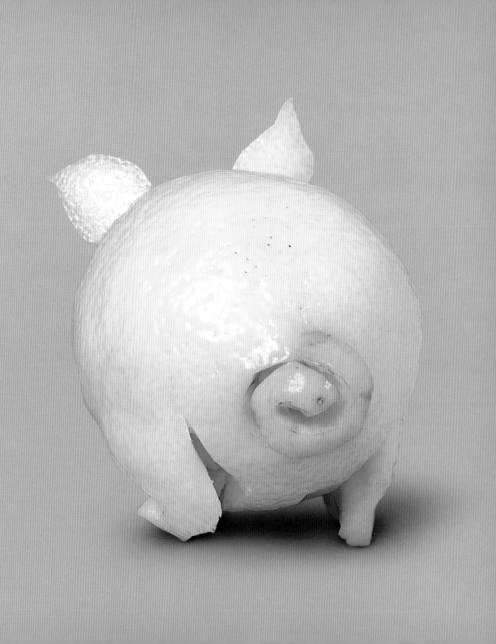

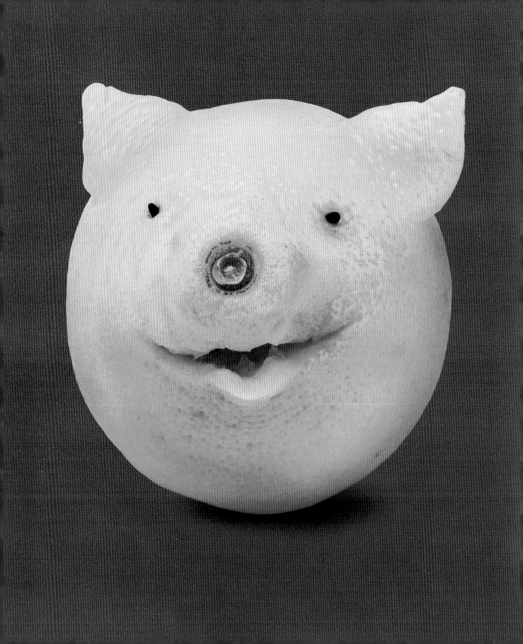

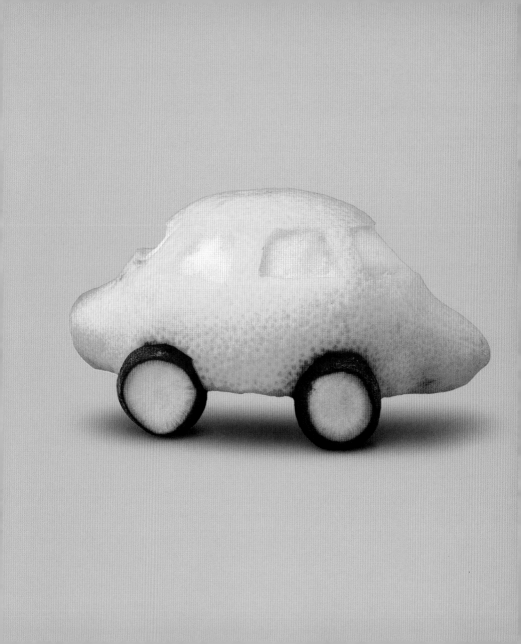

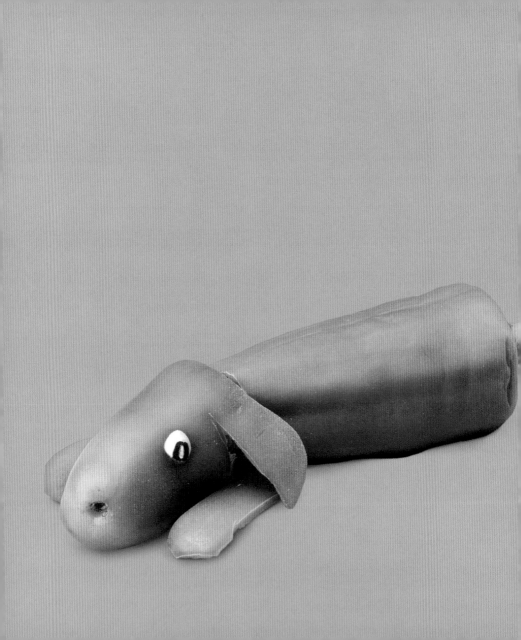

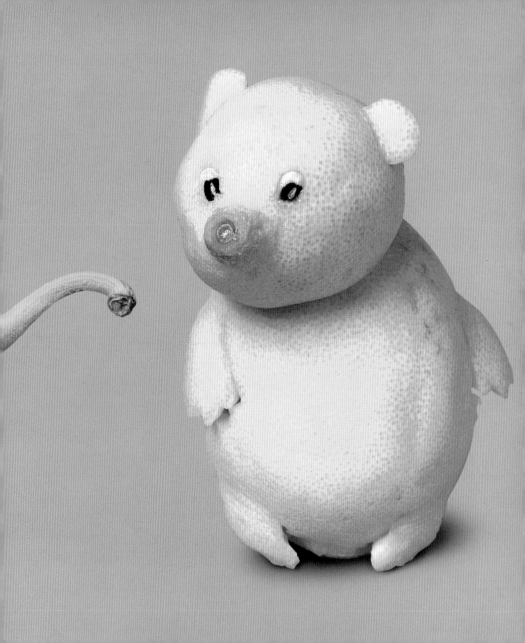

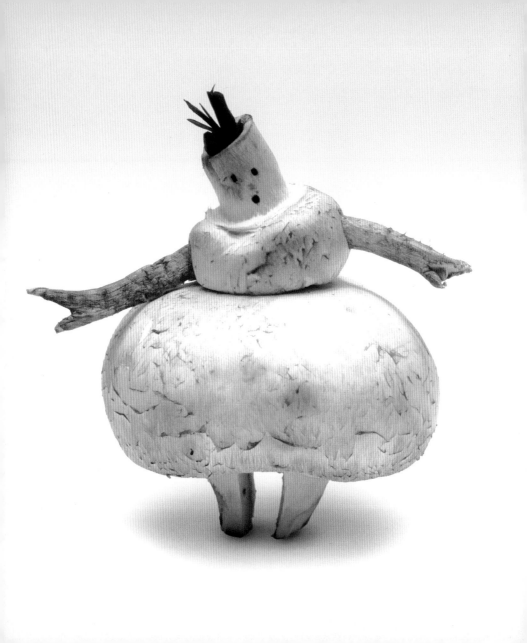

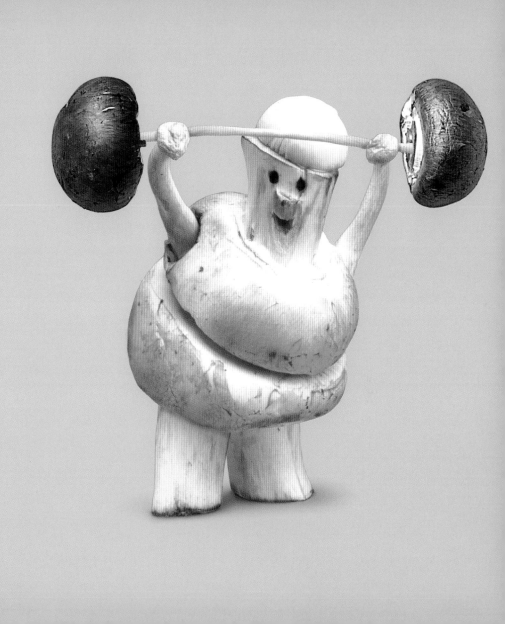

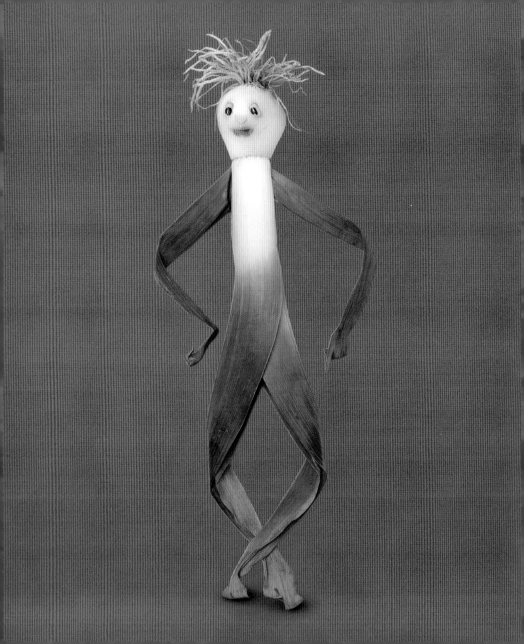

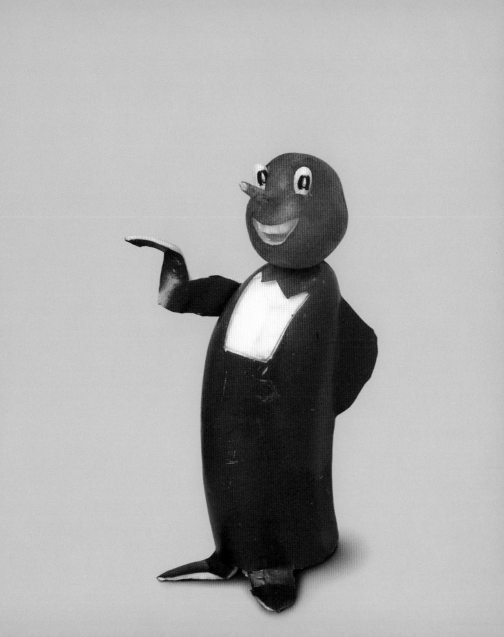

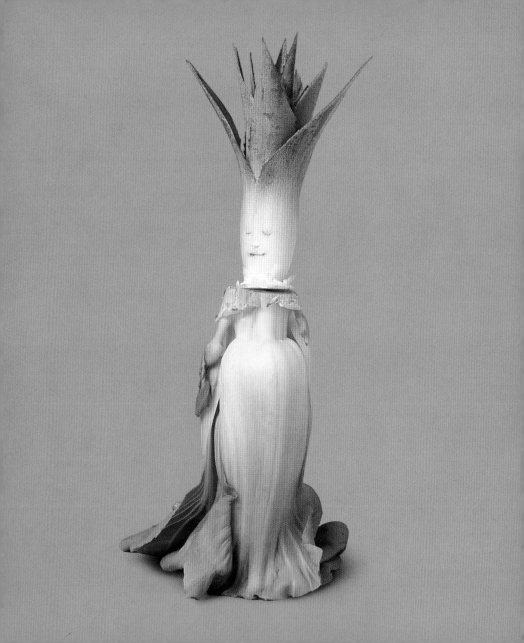

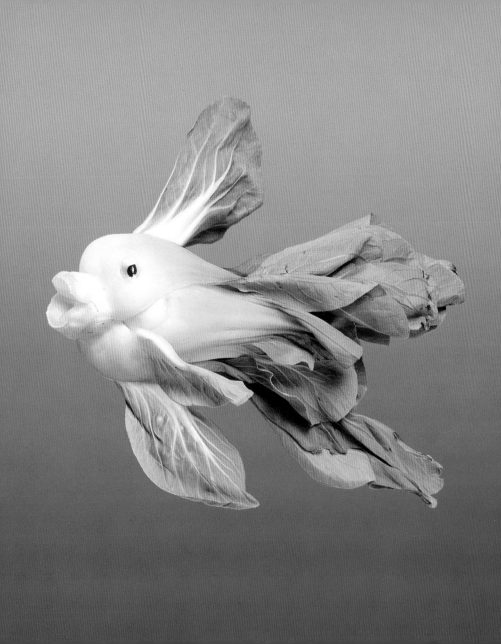

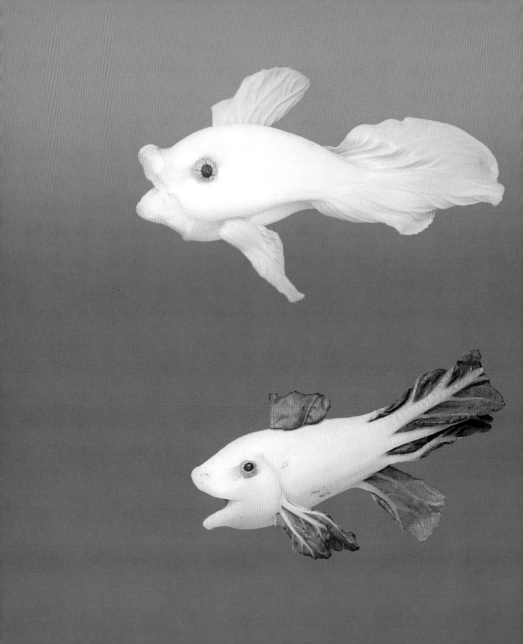

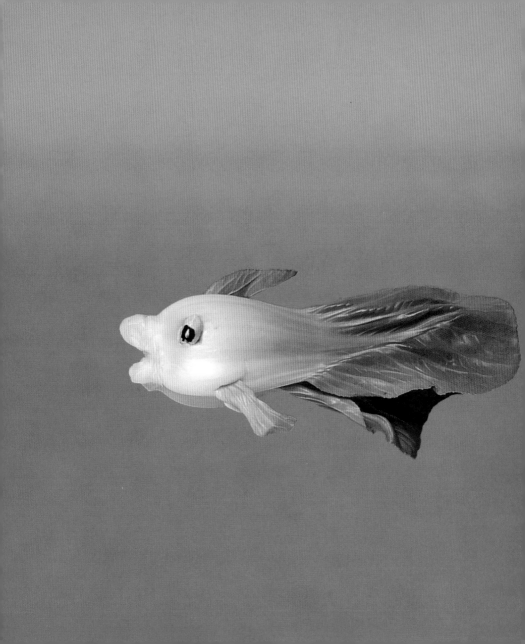

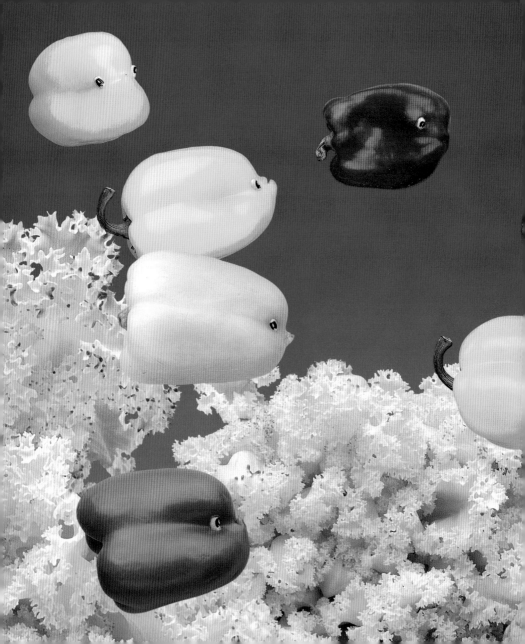

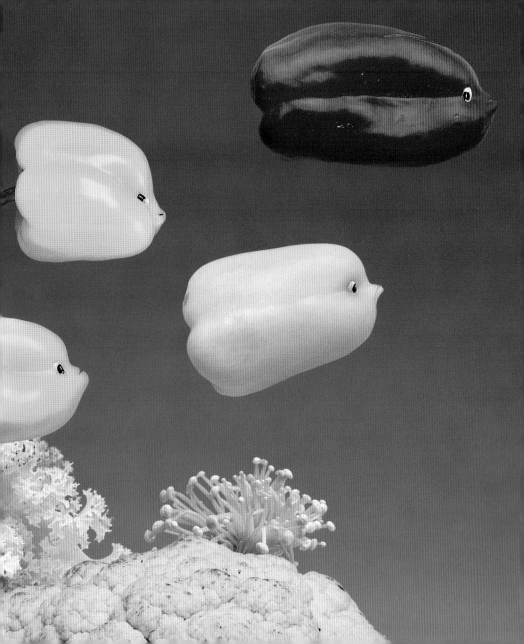

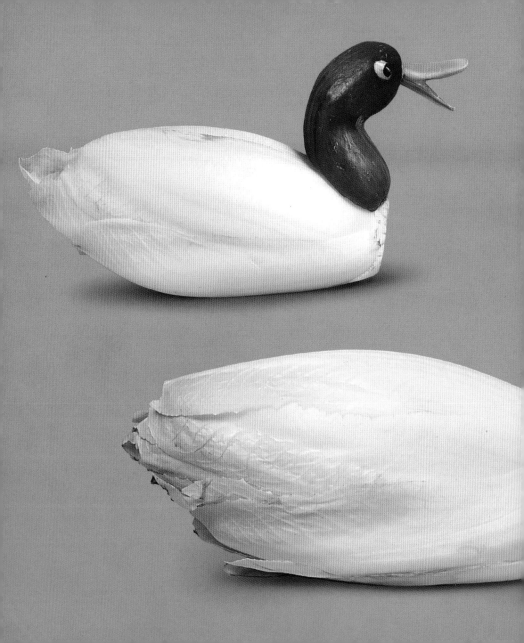

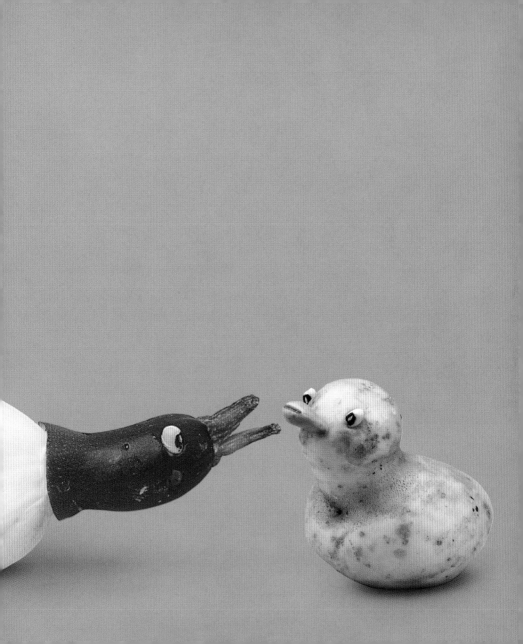

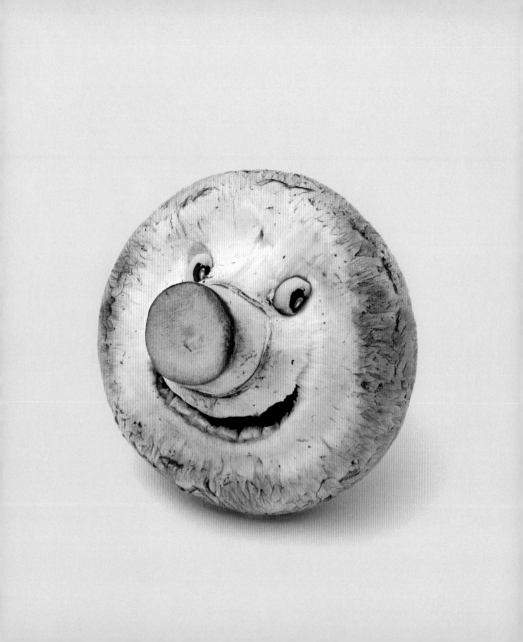

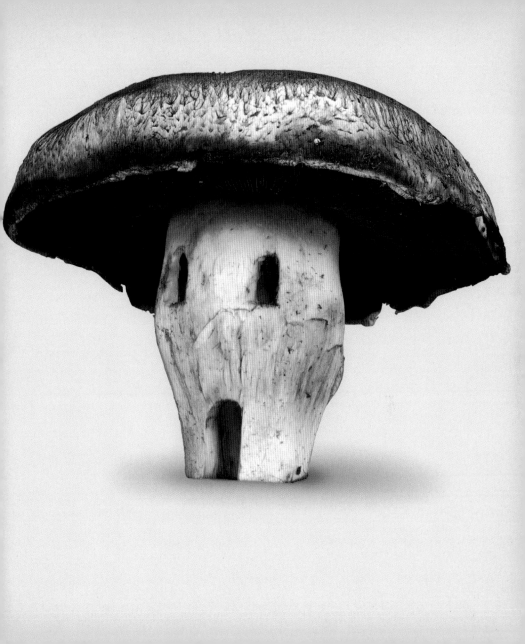

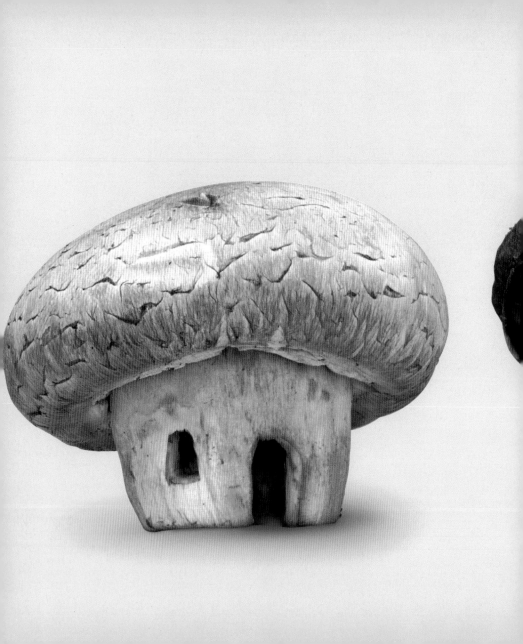

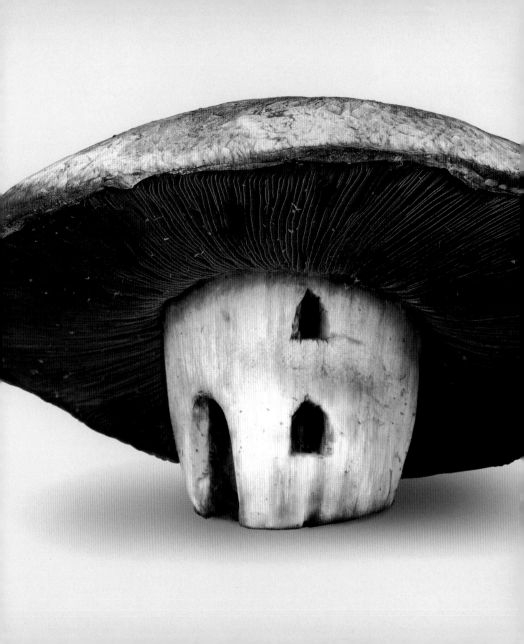

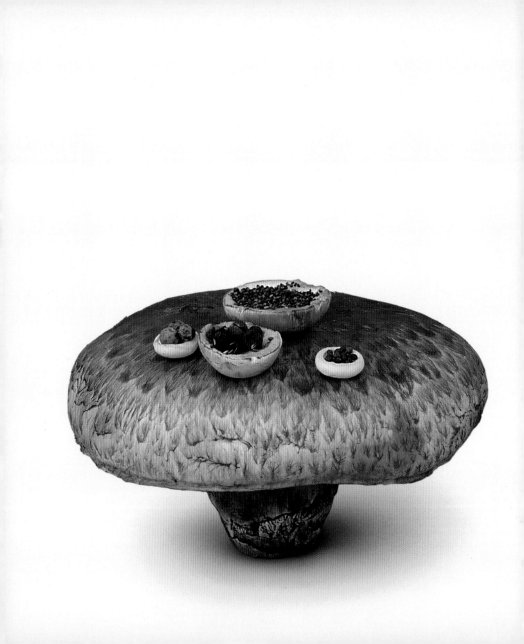

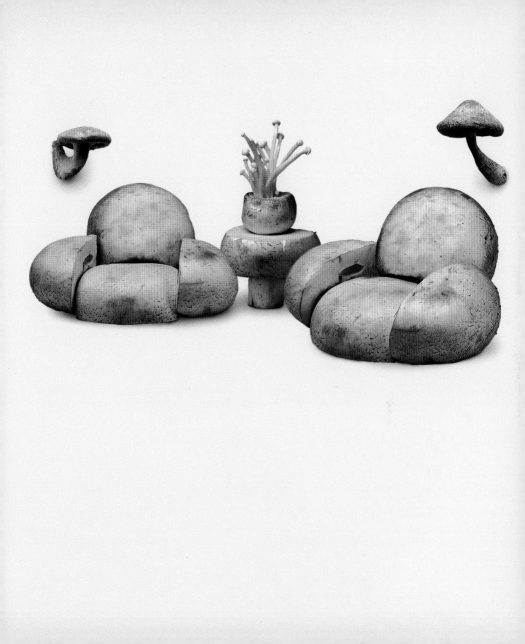

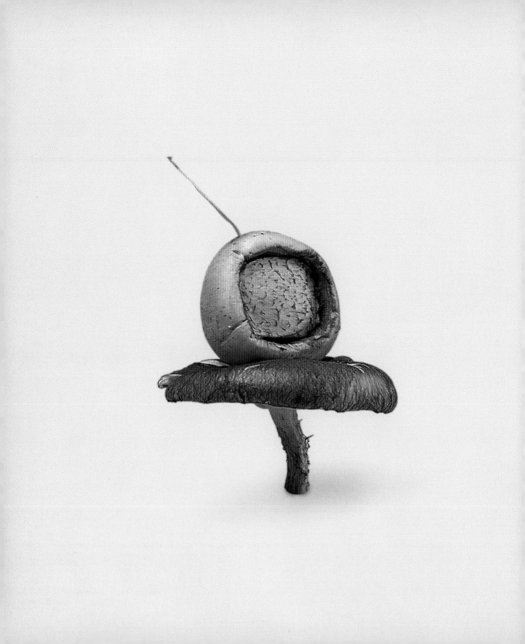

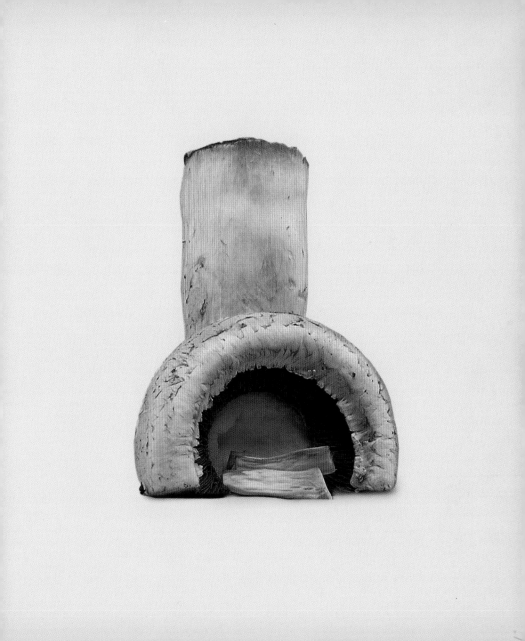

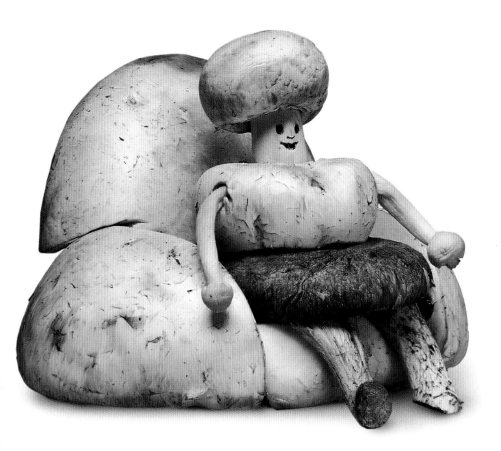

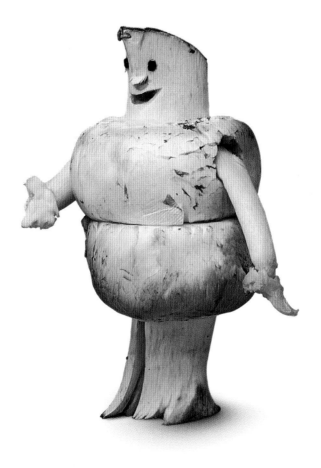

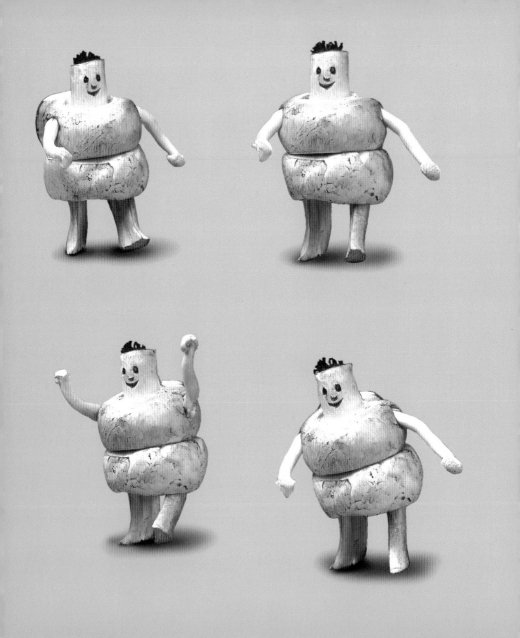

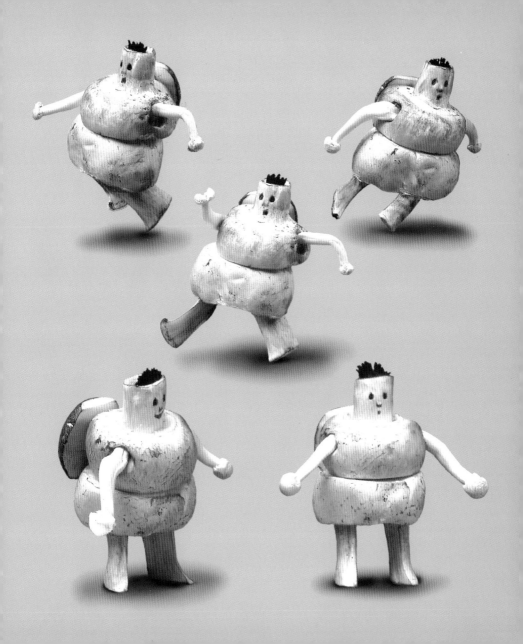

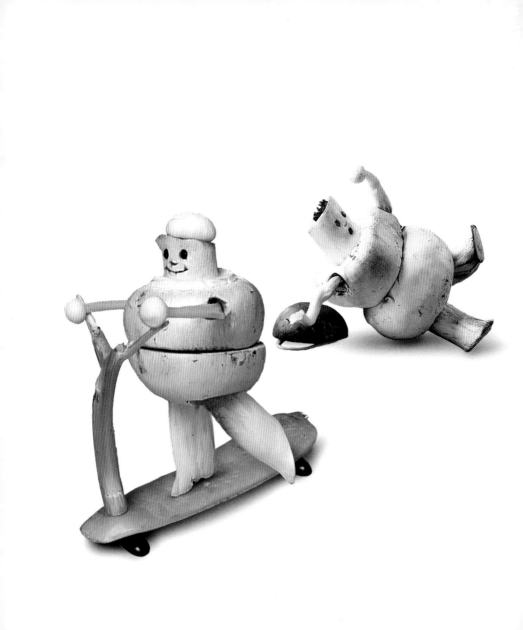

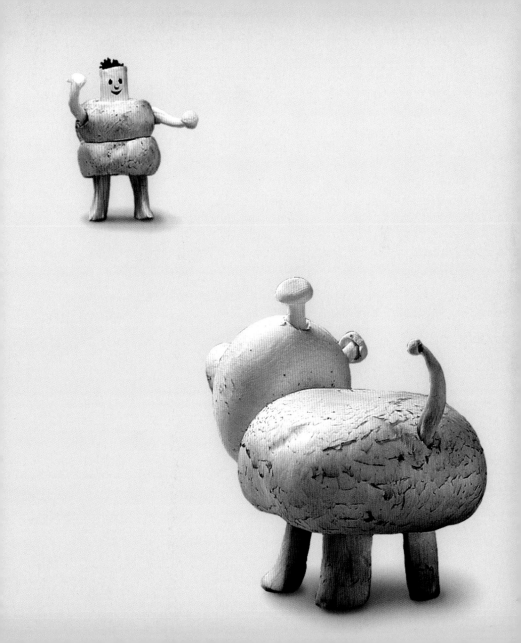

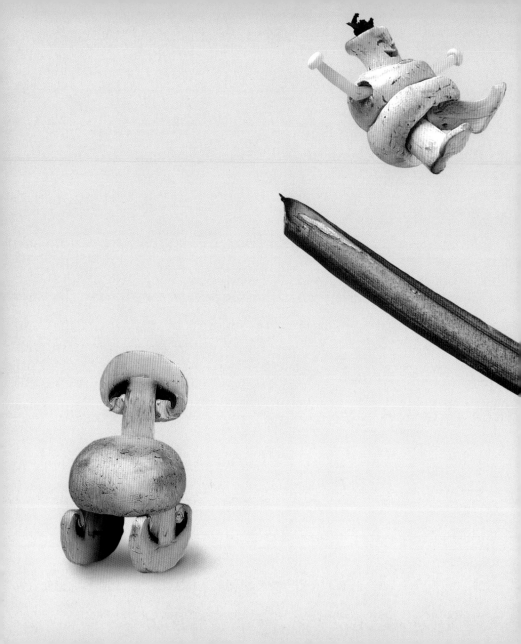

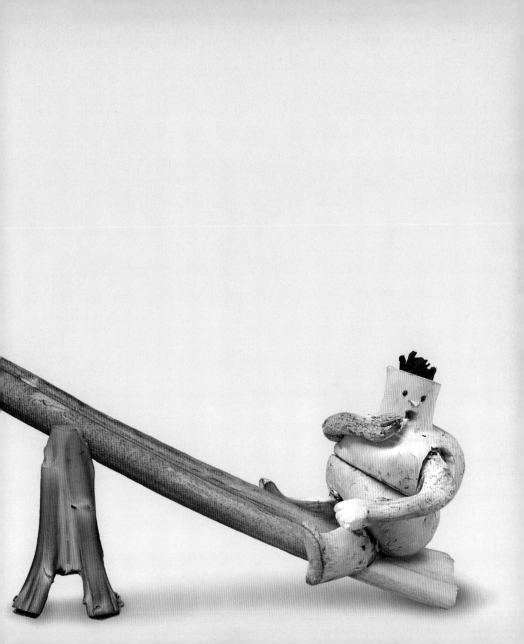

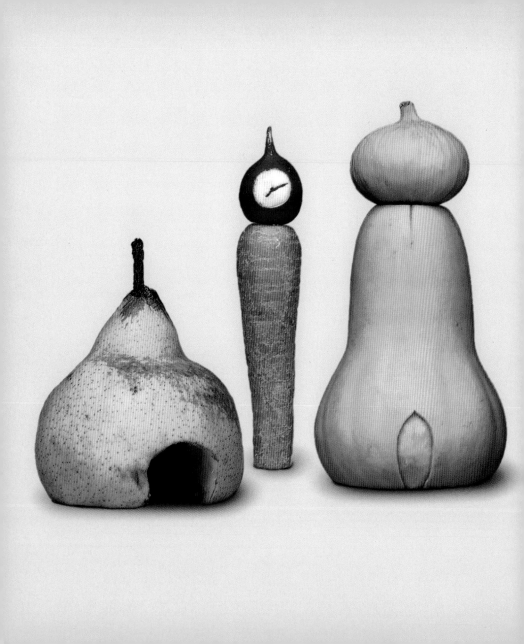

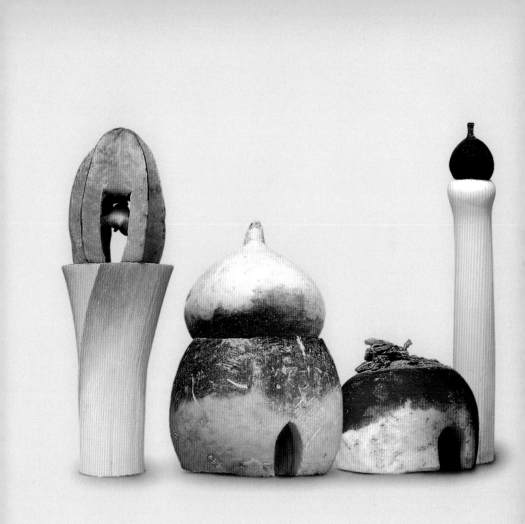

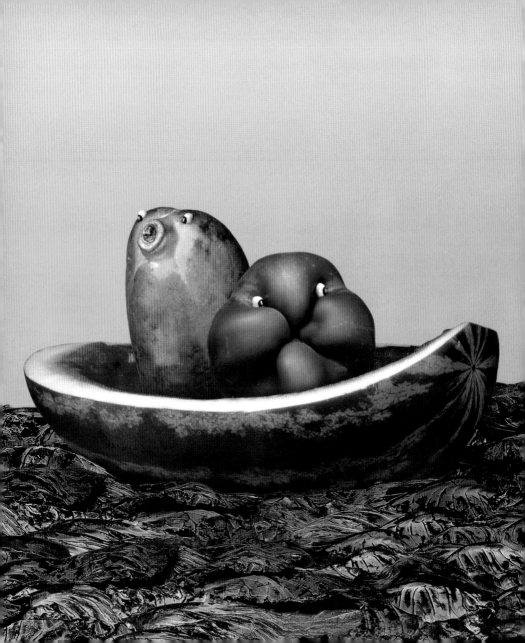

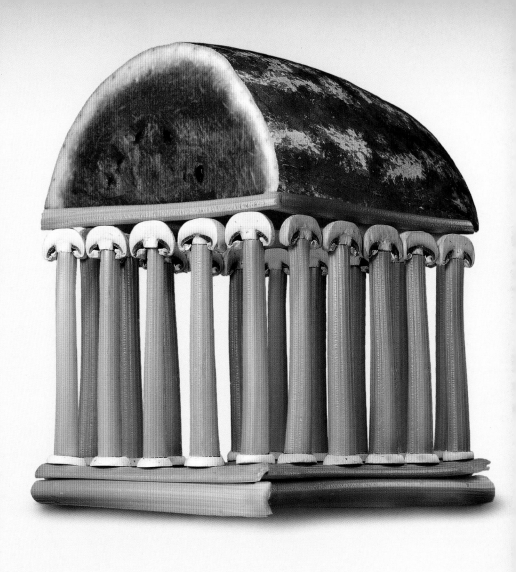

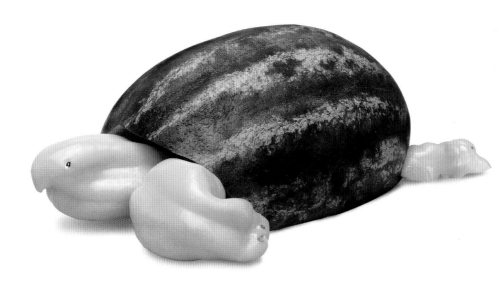

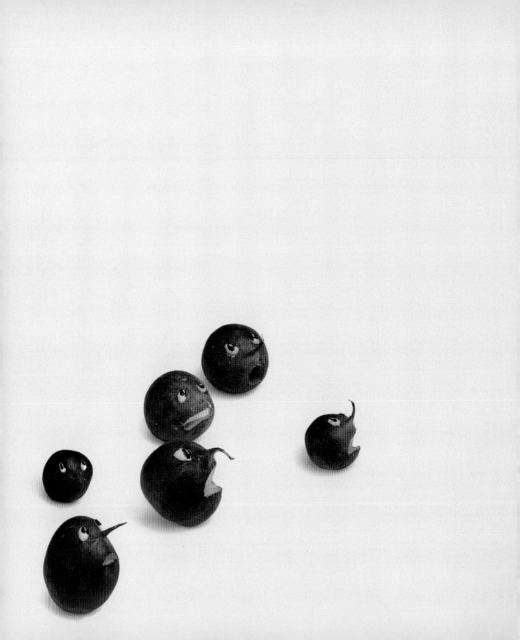

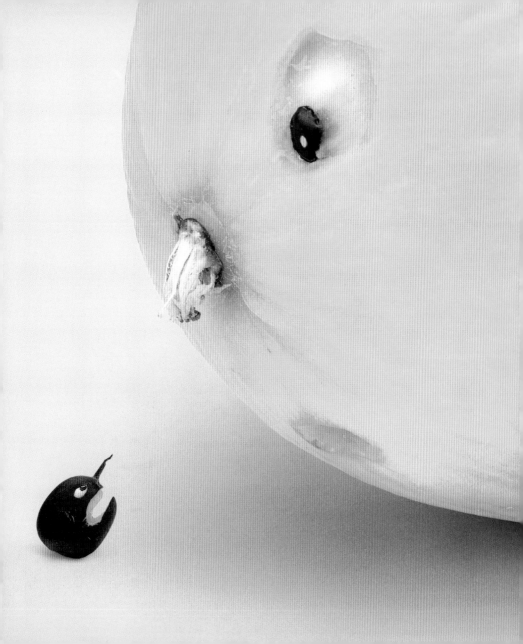

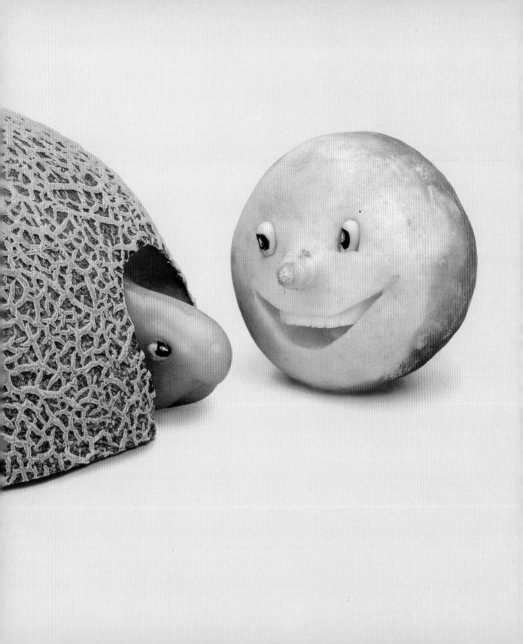

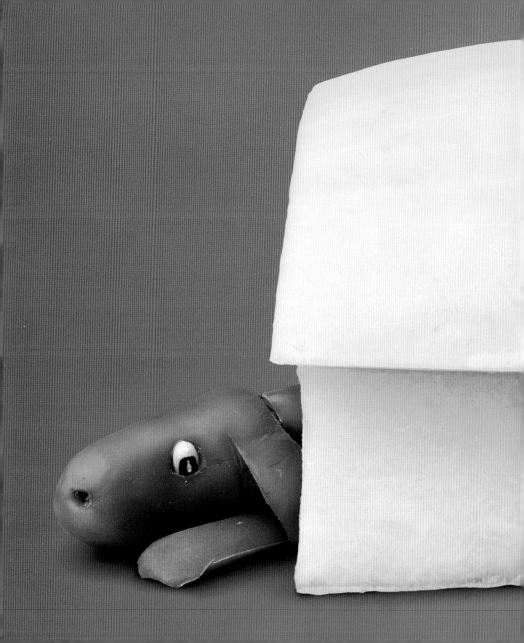

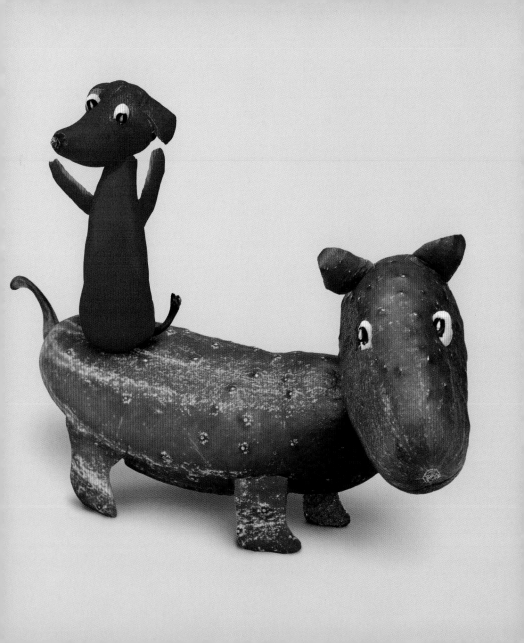

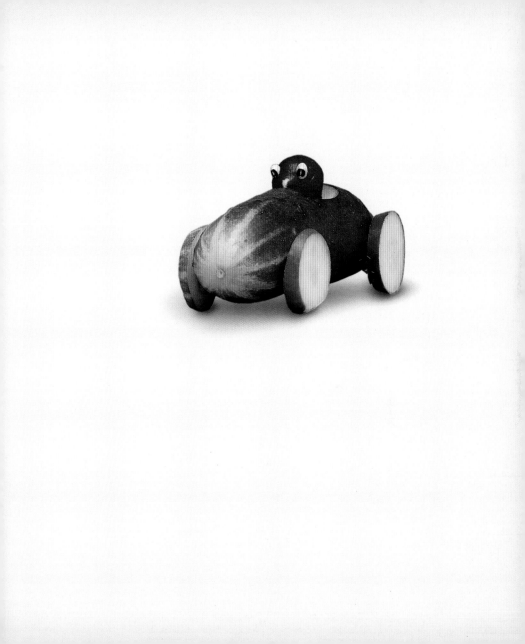

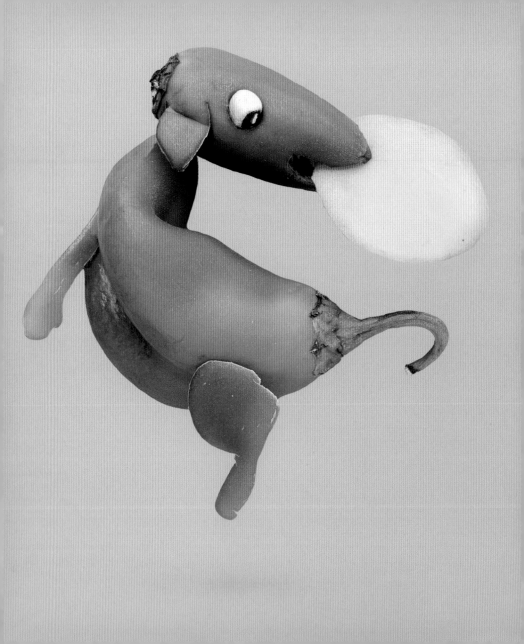

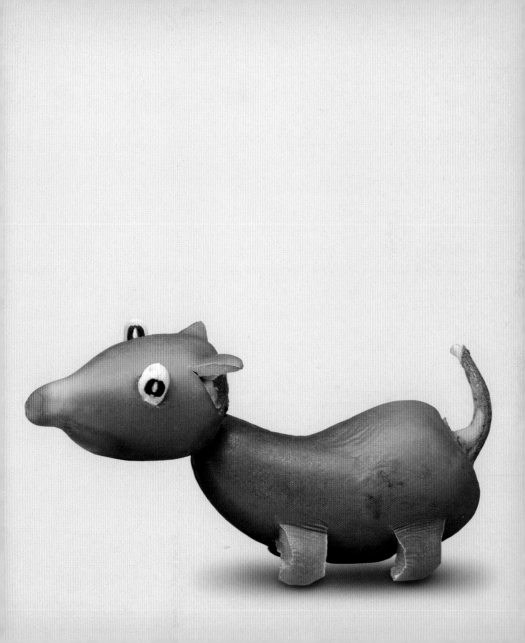

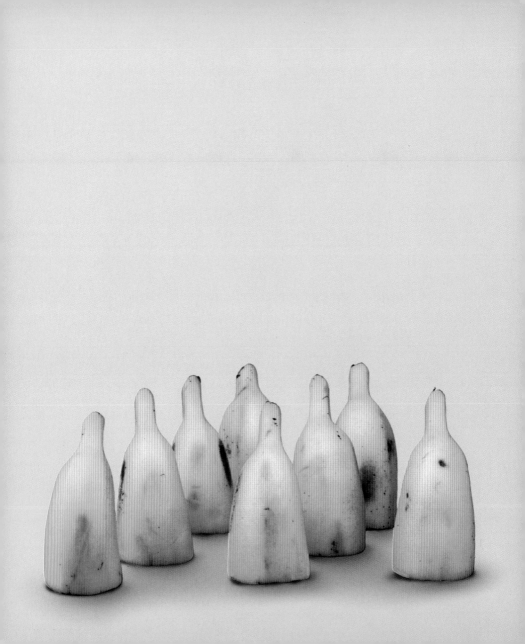

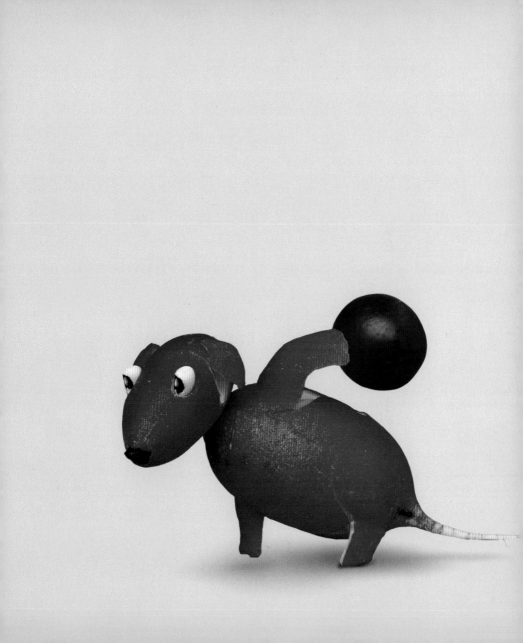

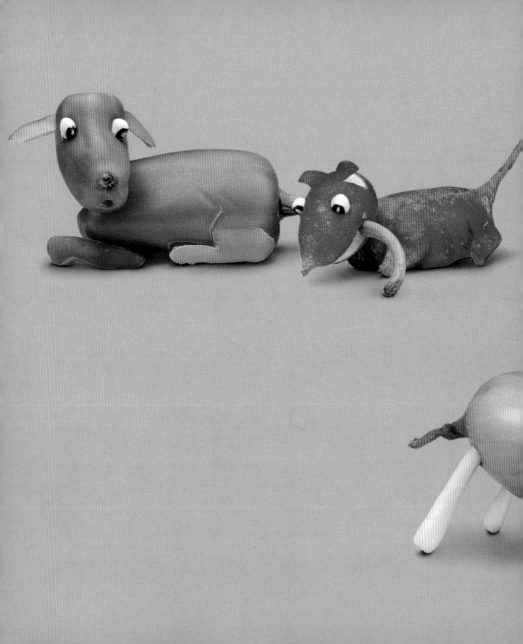

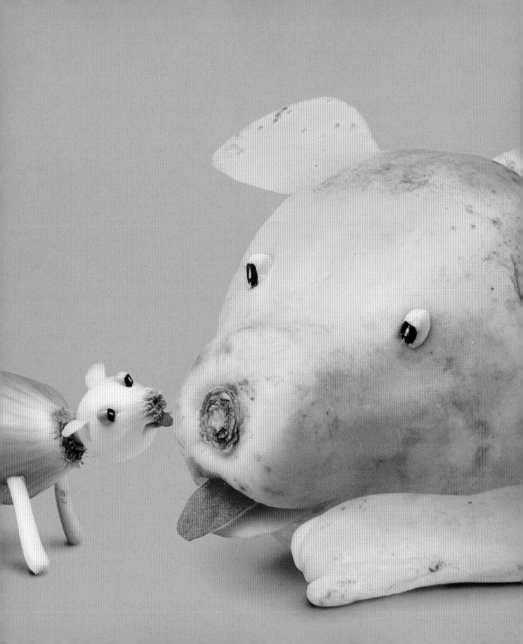

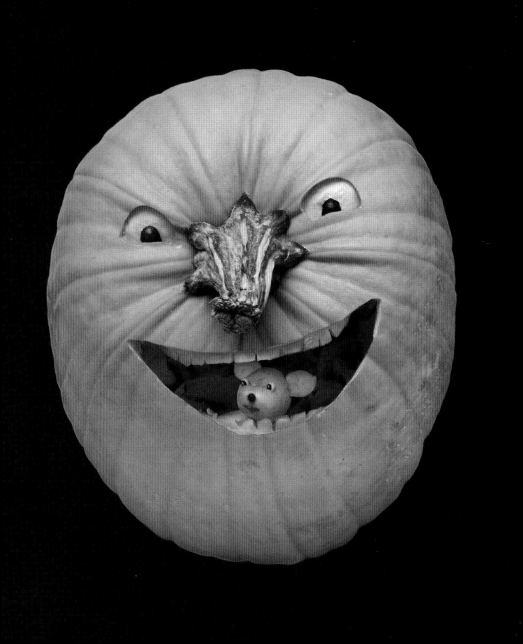

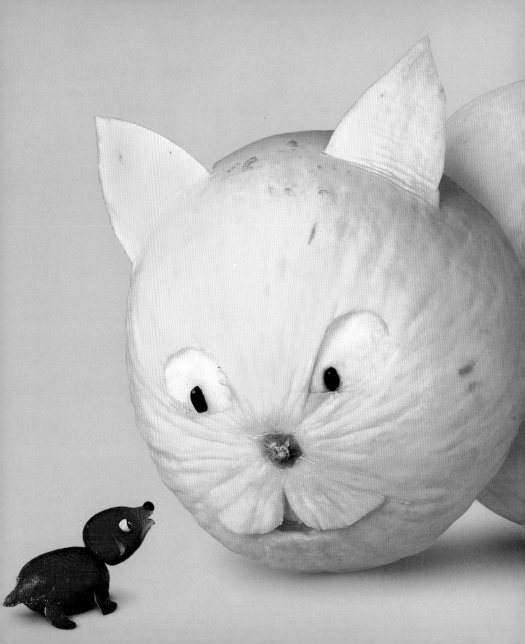

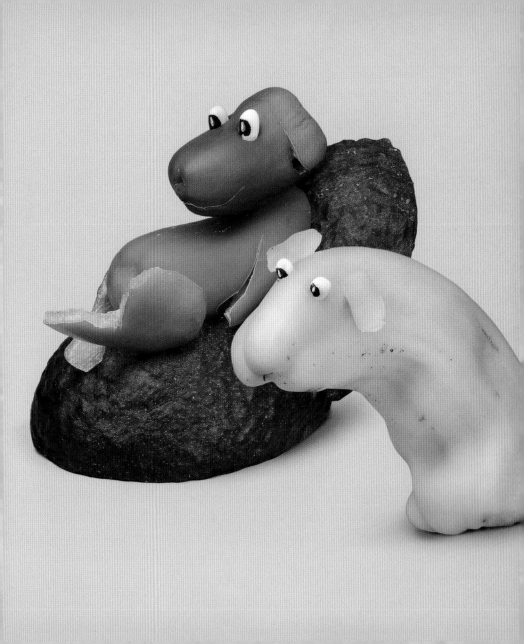

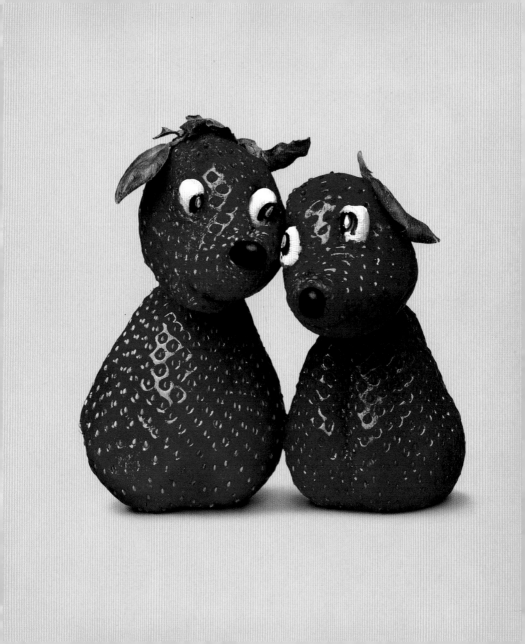

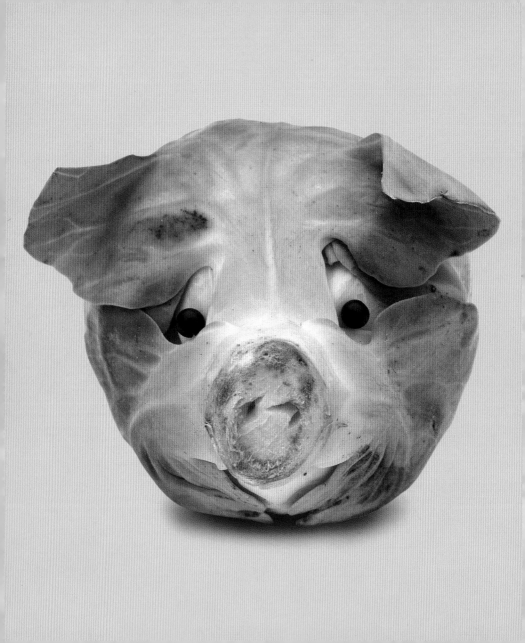

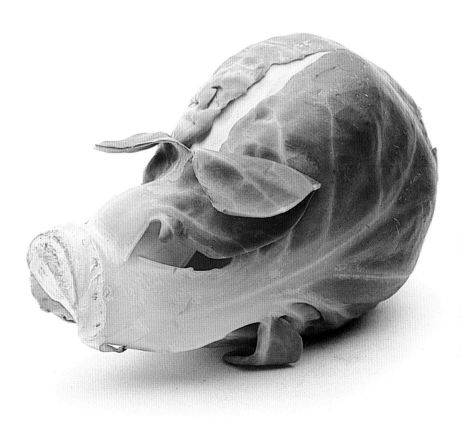

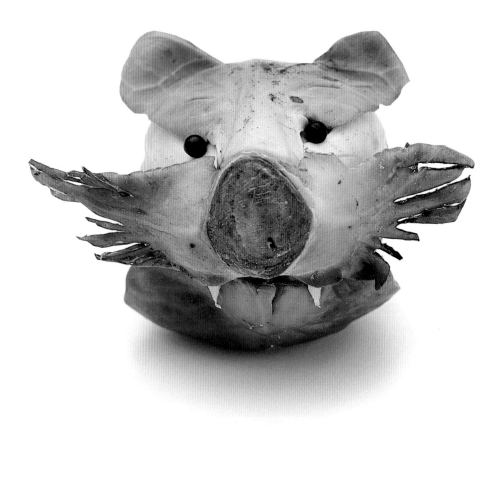

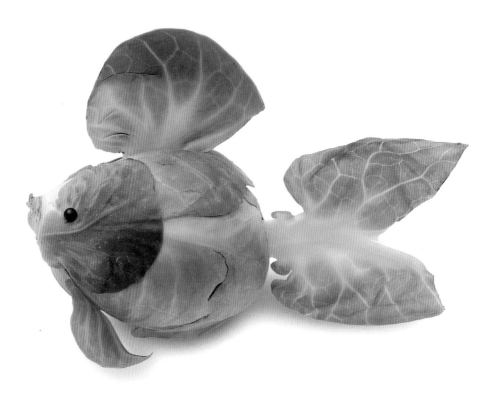

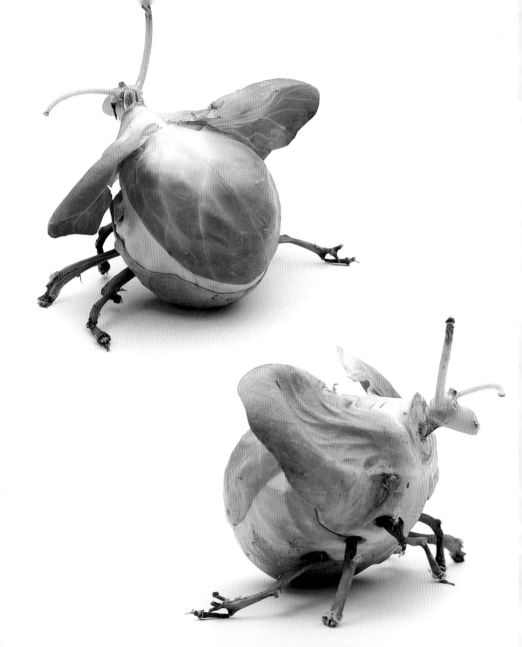

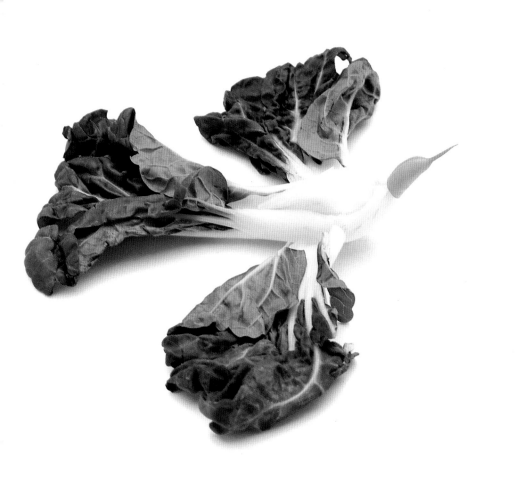

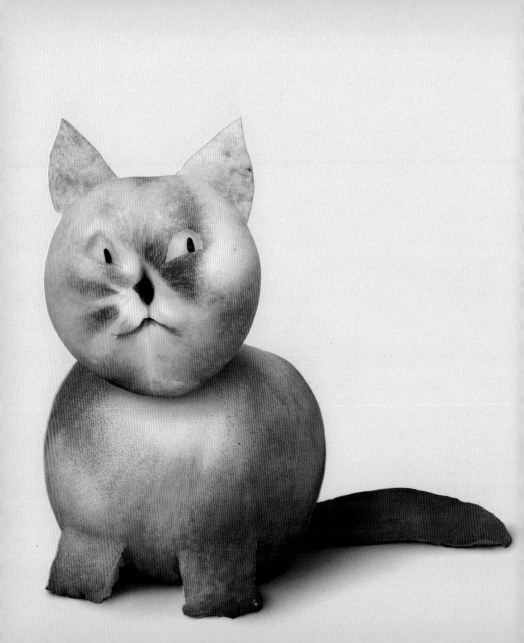

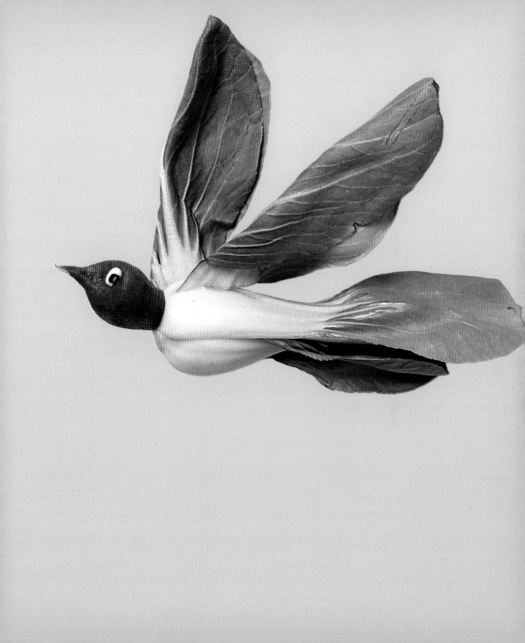

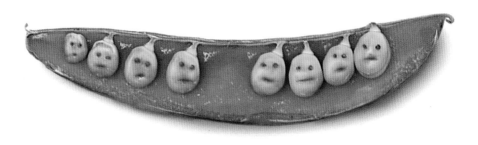

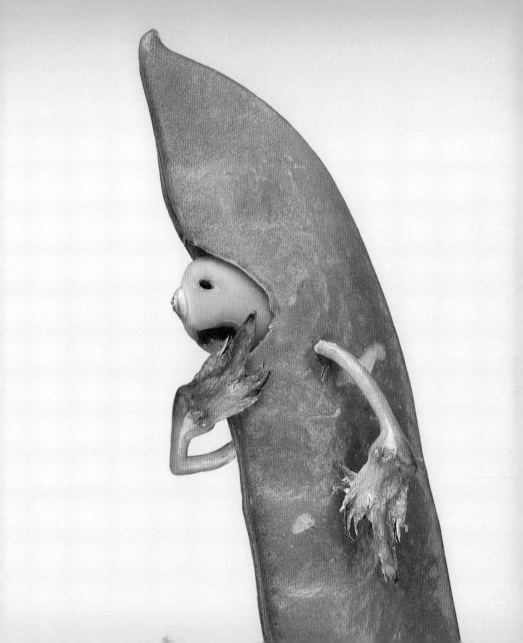

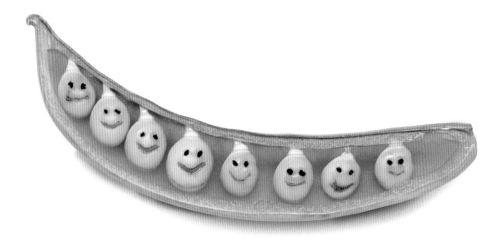

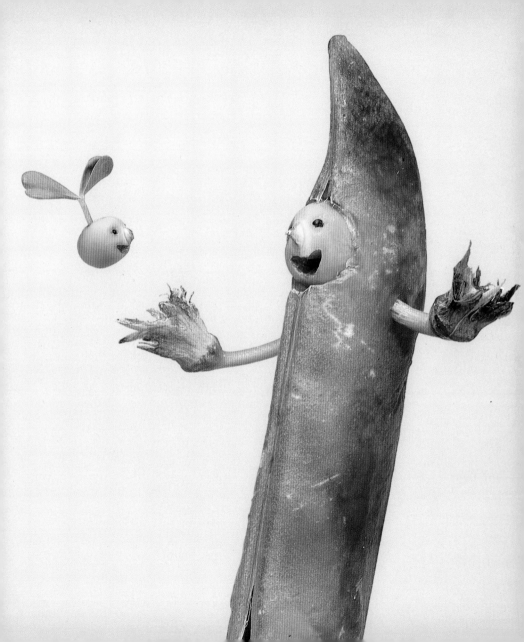

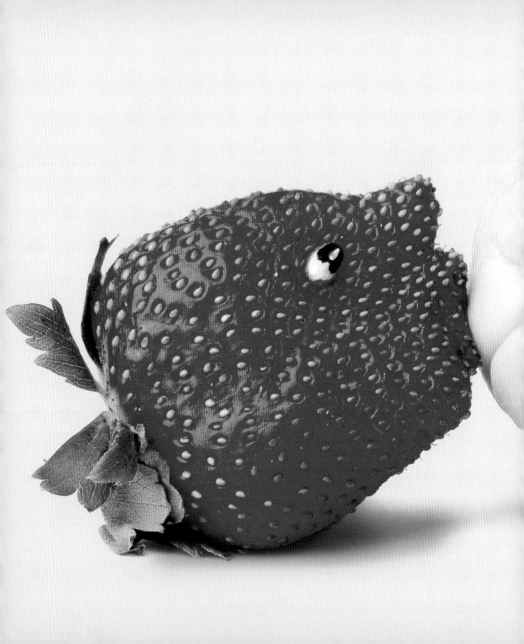

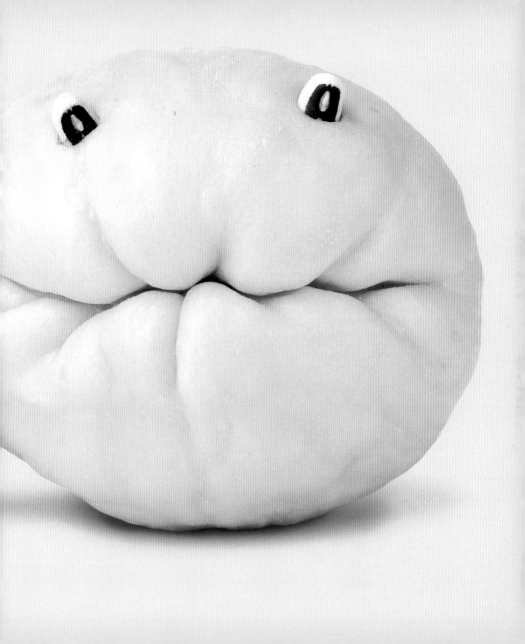

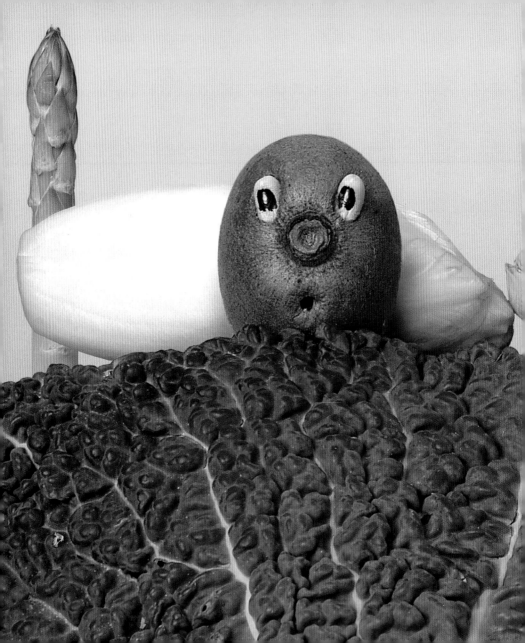

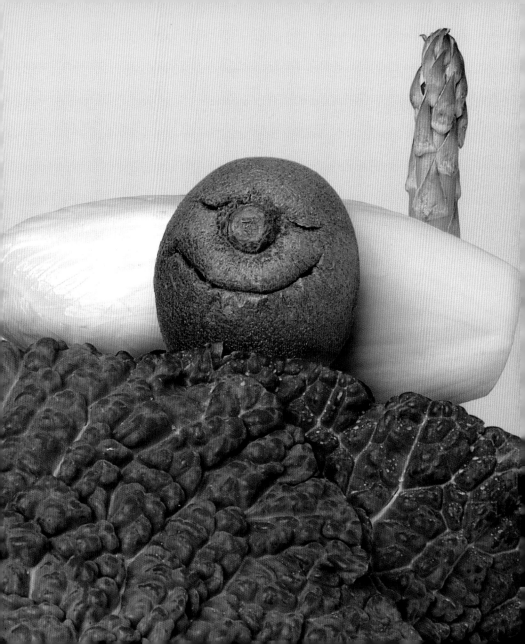

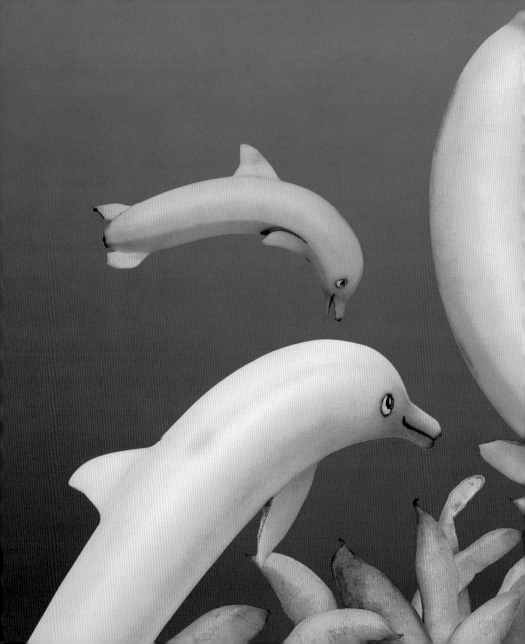

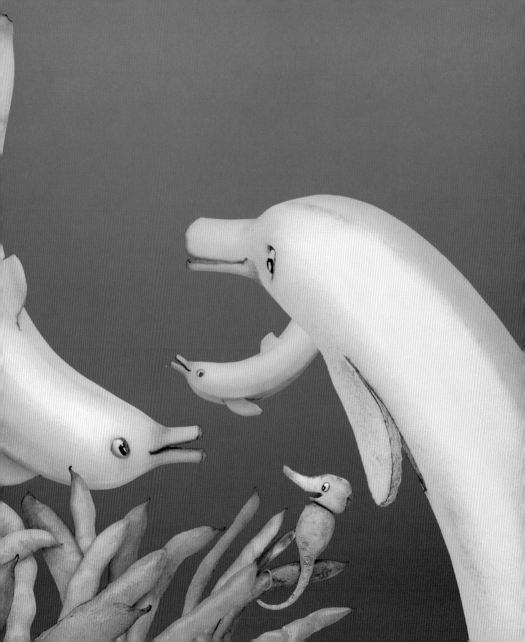

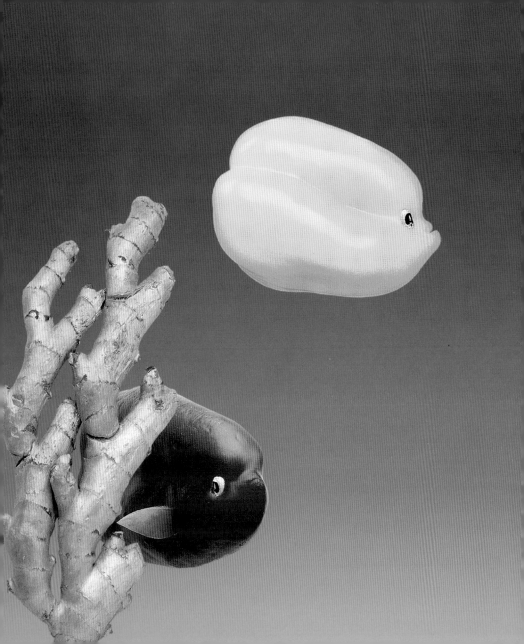

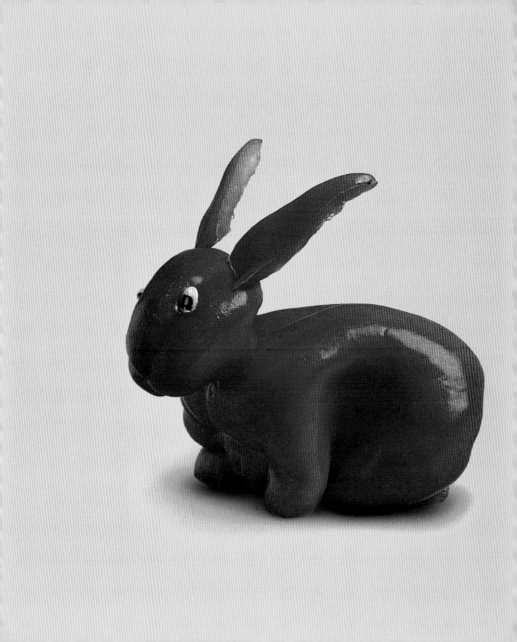

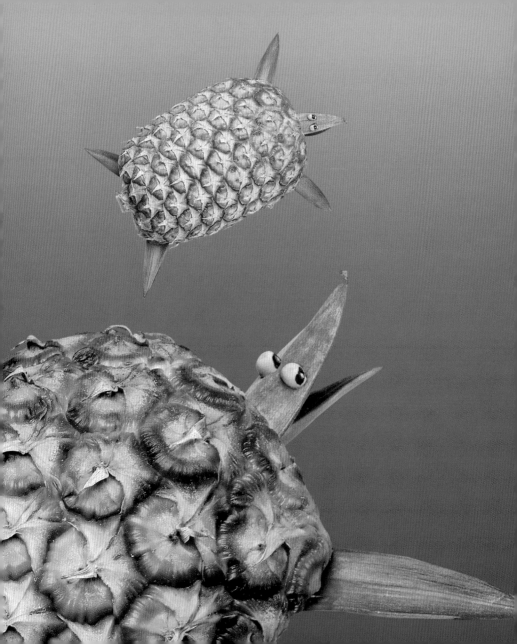

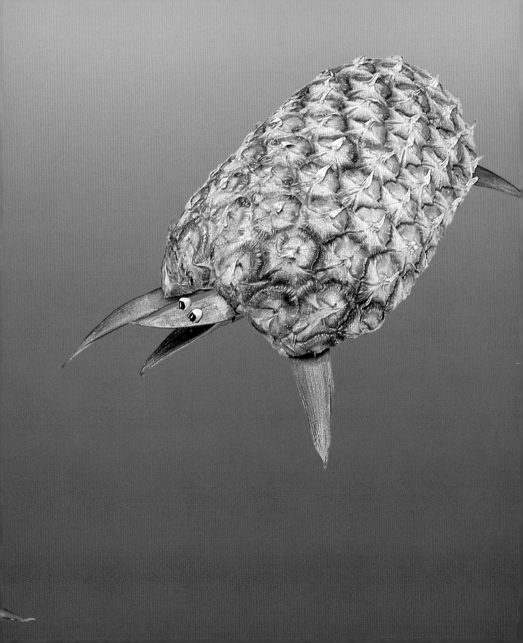

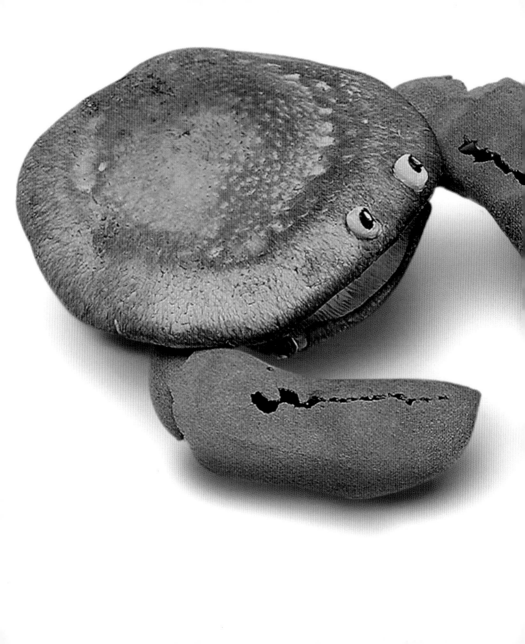

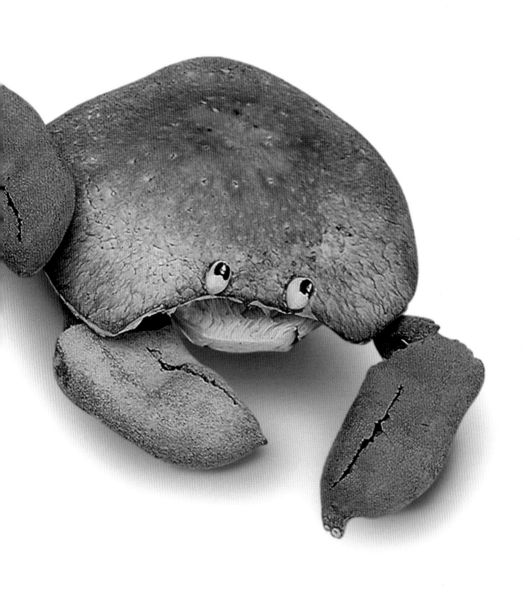

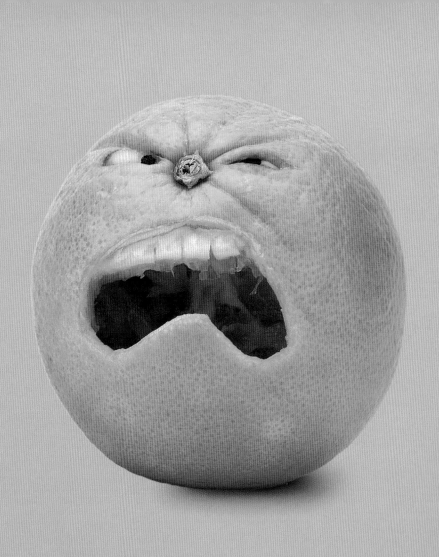

1

2

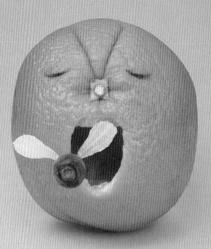

5

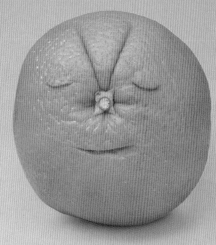

6

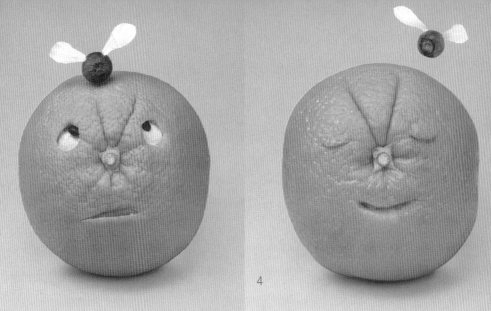

3

4

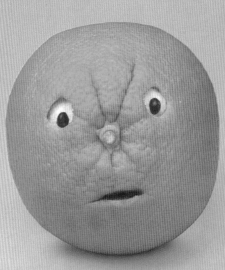

7

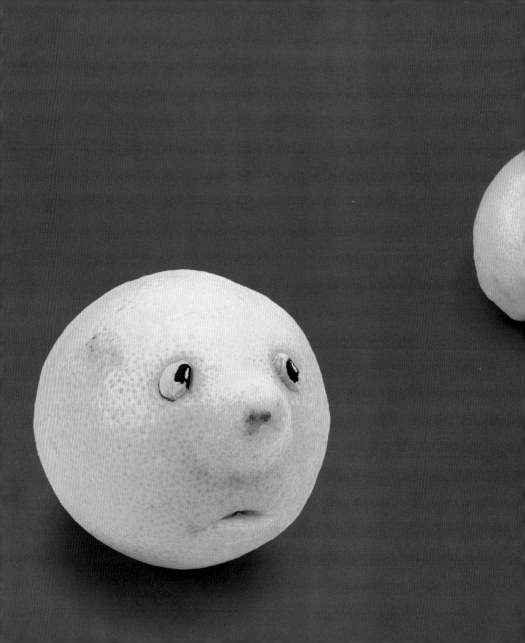

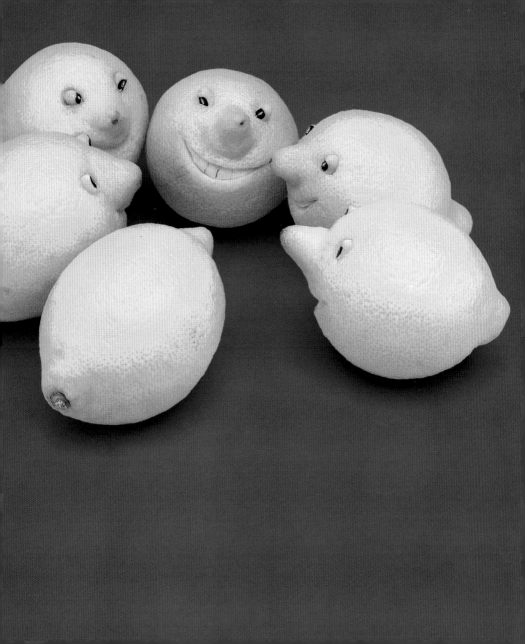

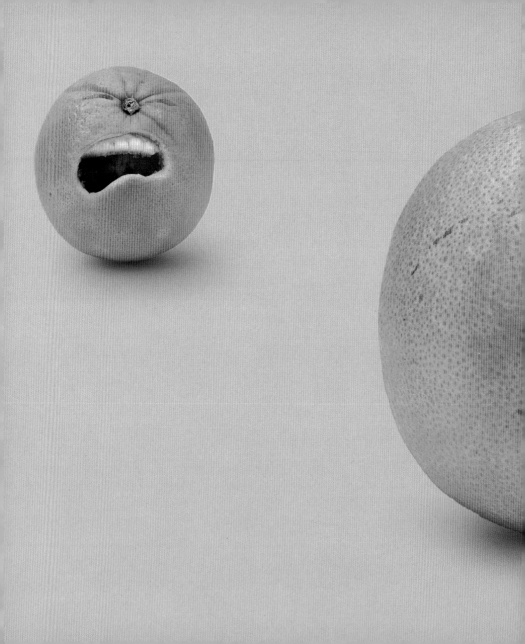

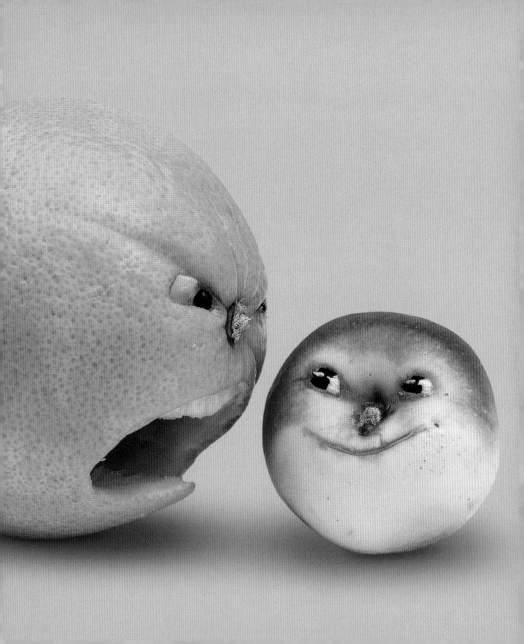

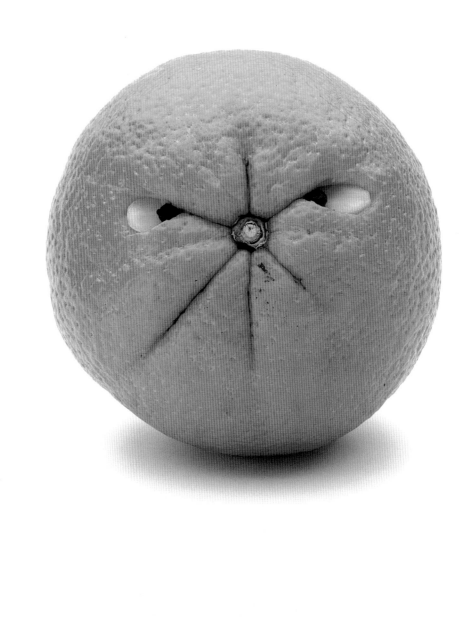

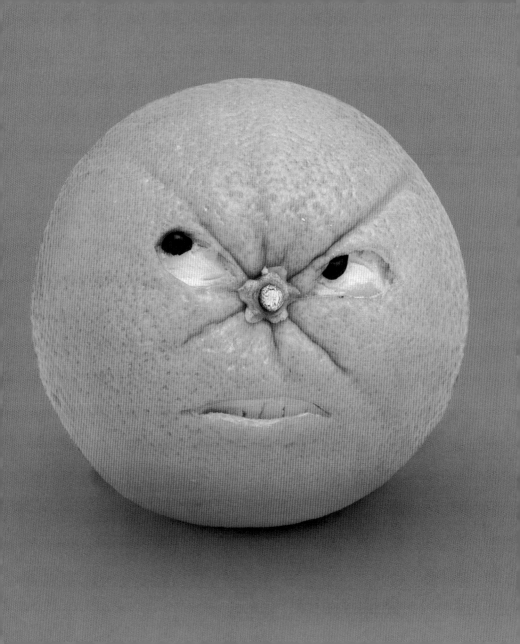

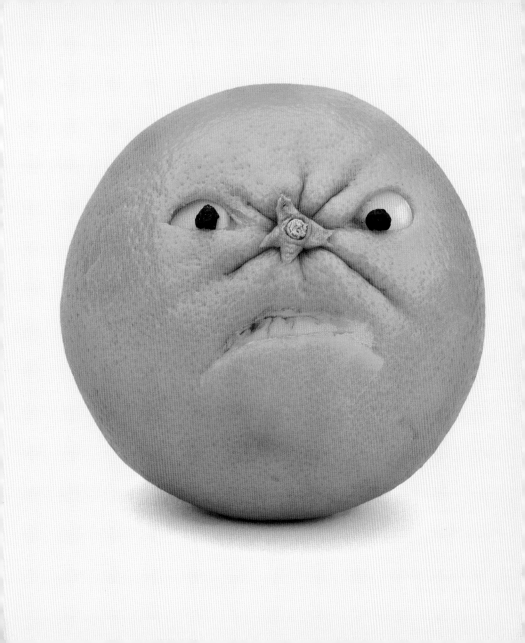

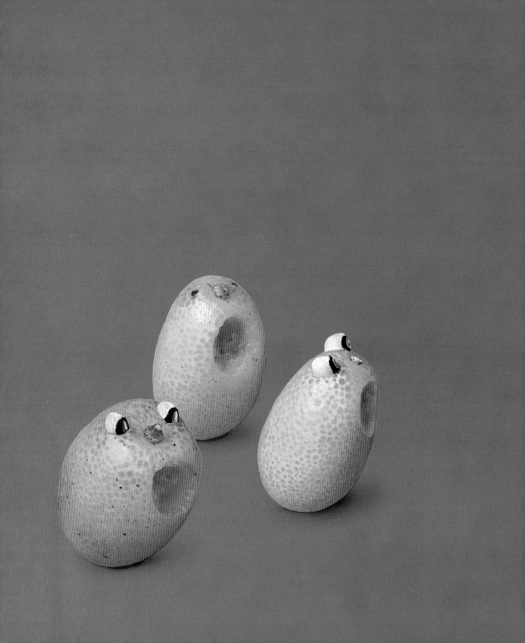

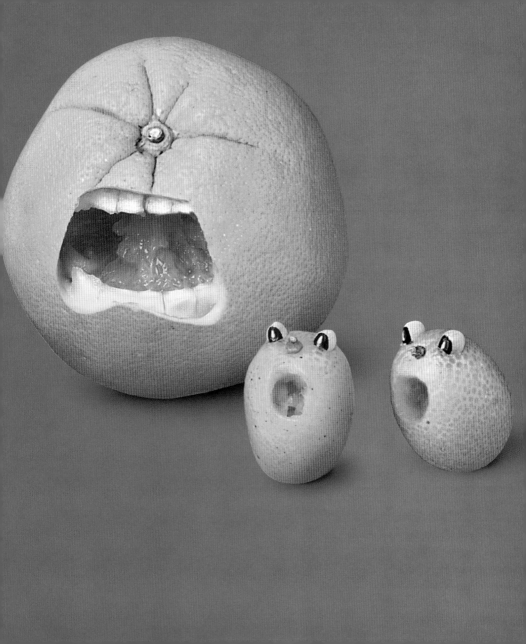

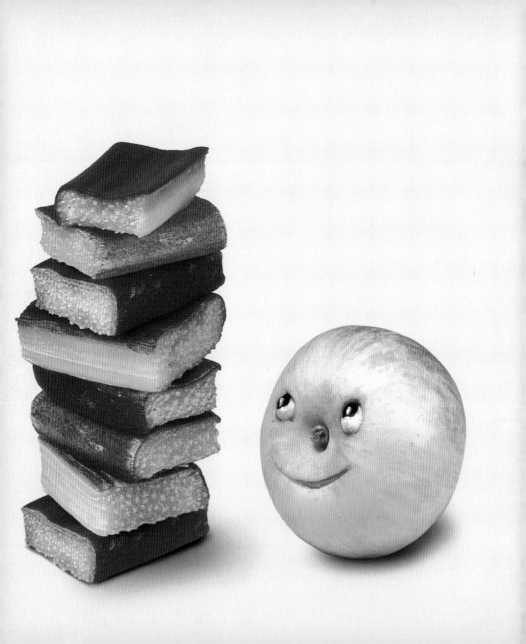

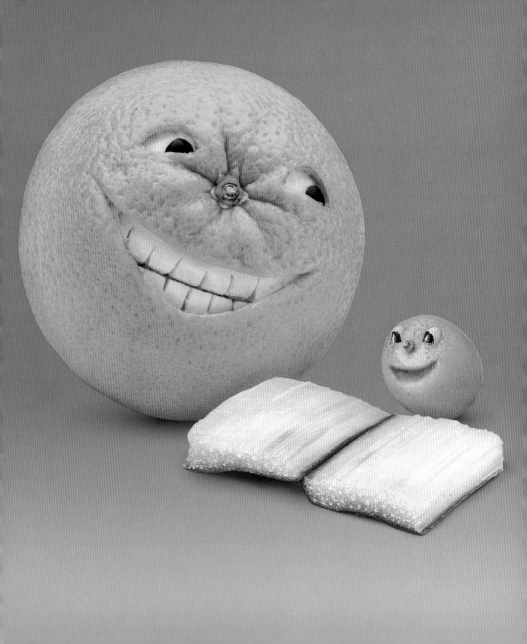

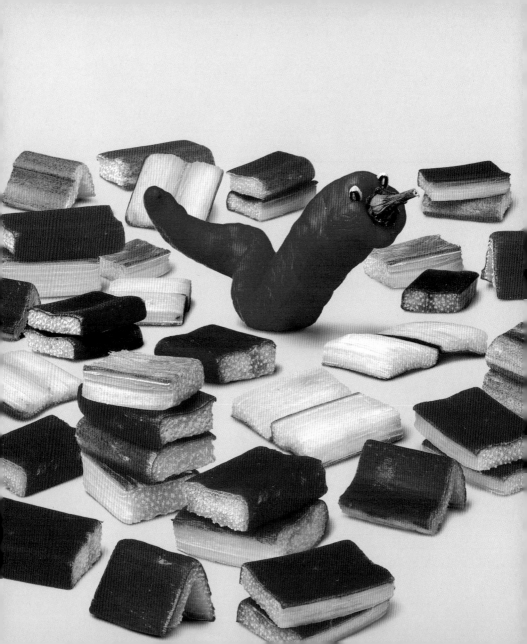

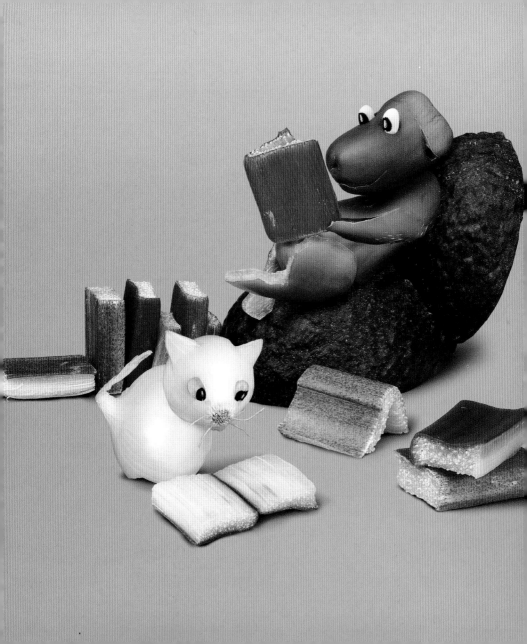

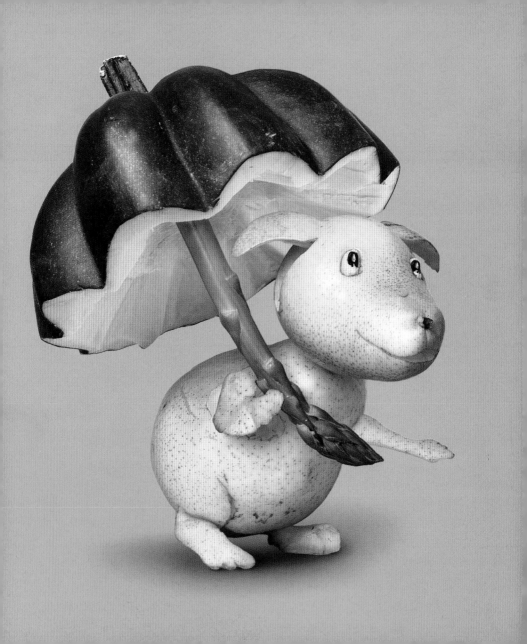

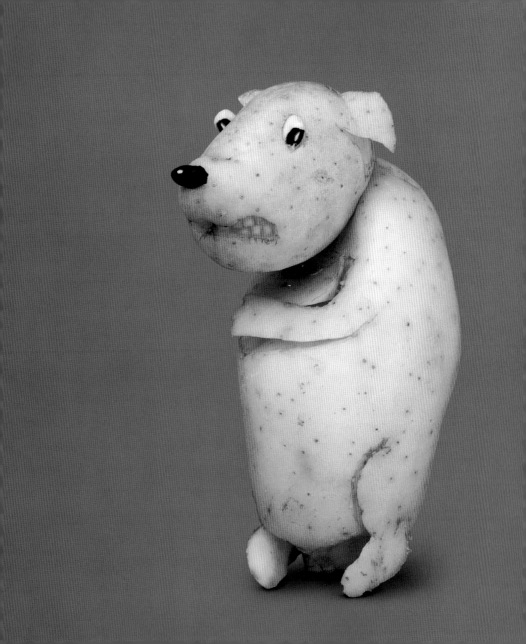

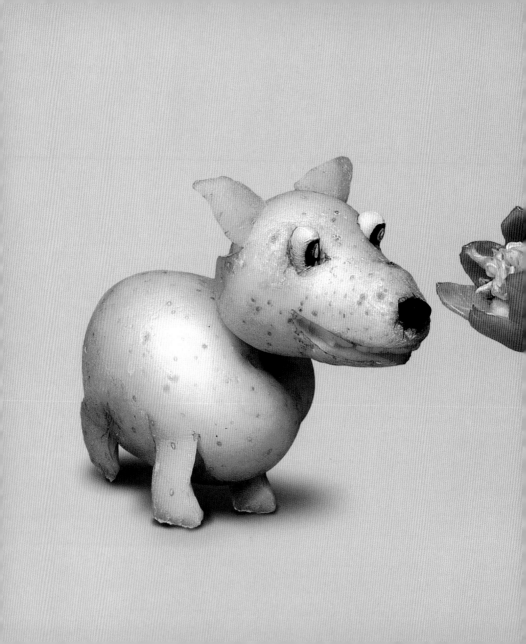

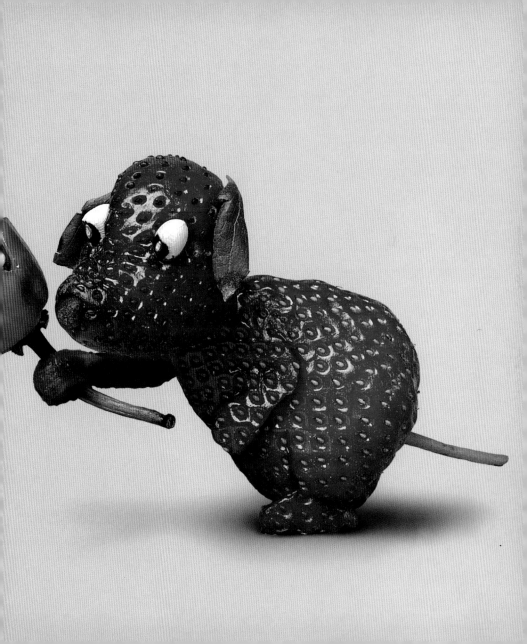

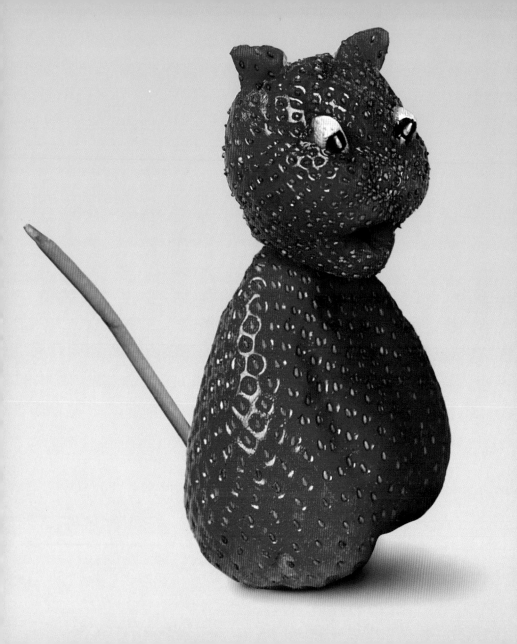

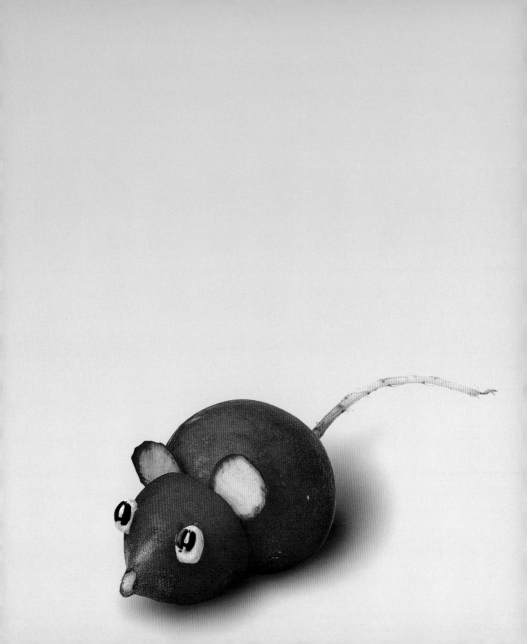

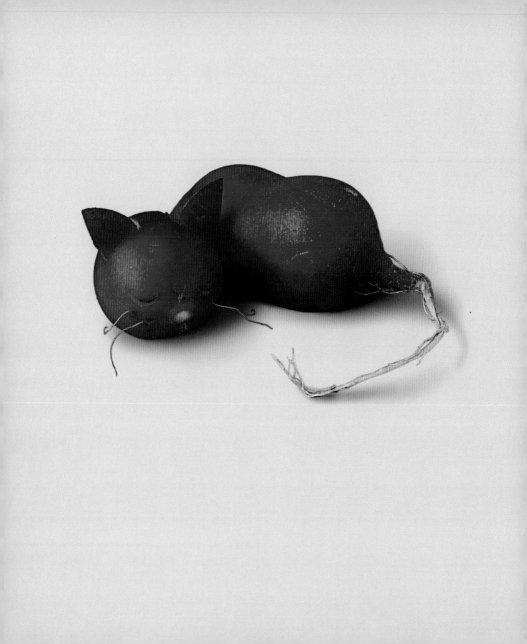

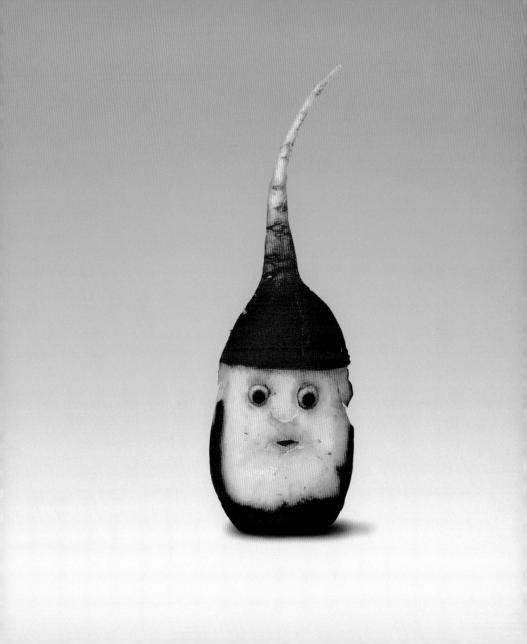

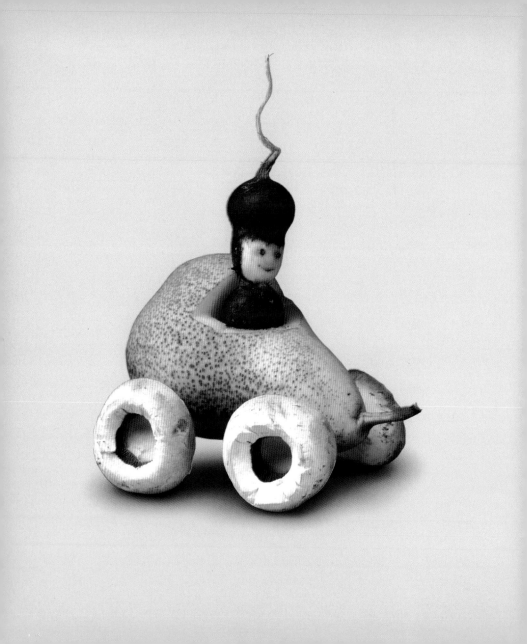

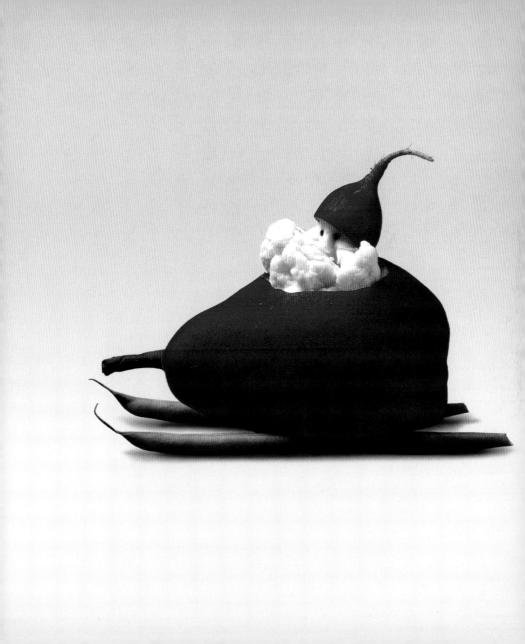

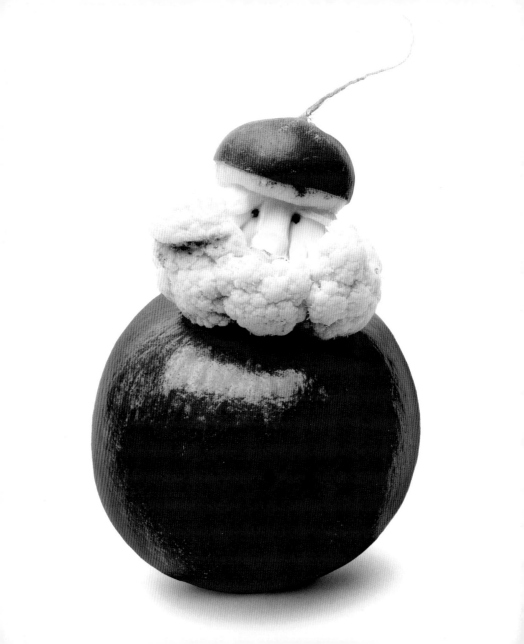

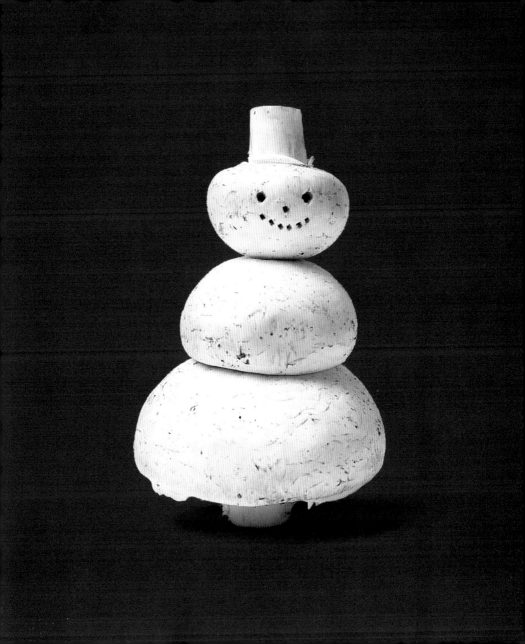

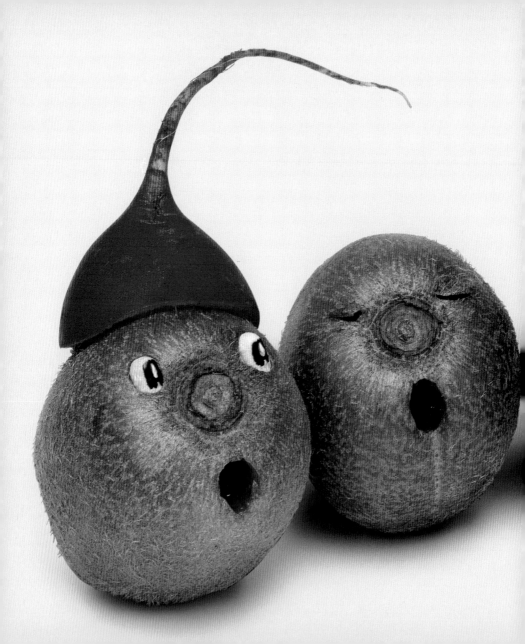

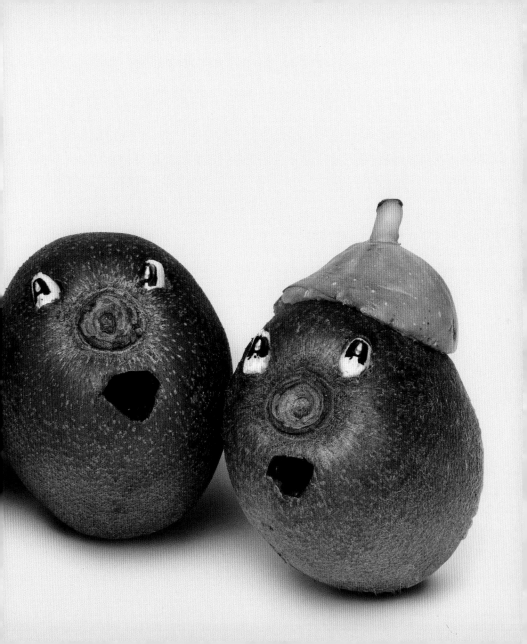

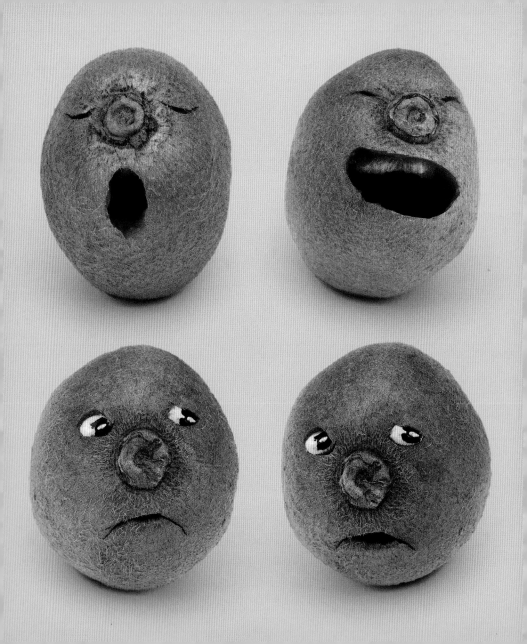

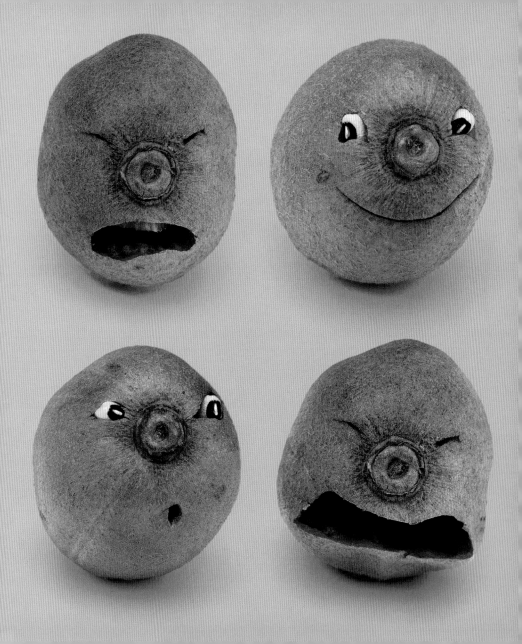

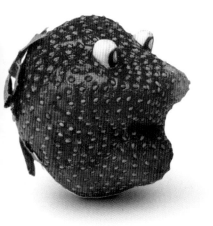
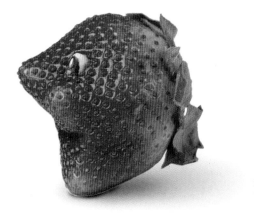

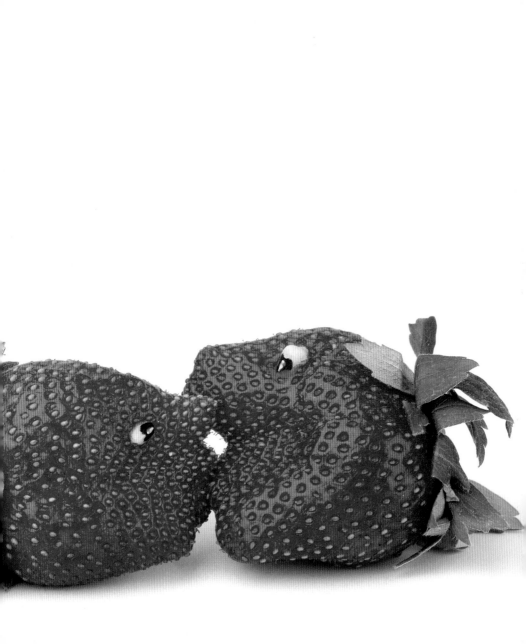

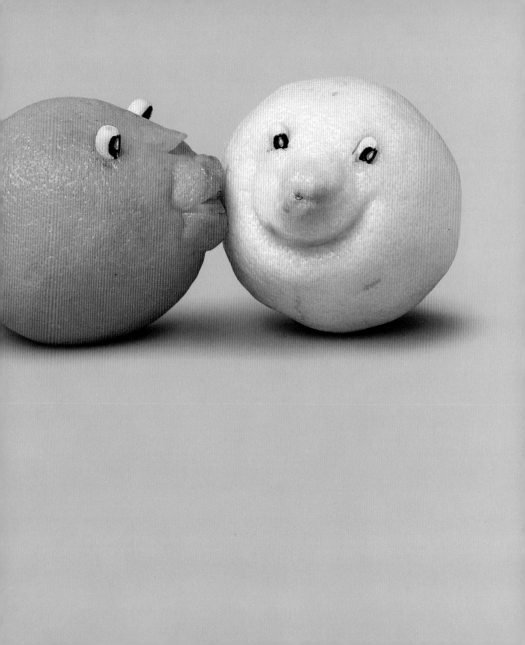

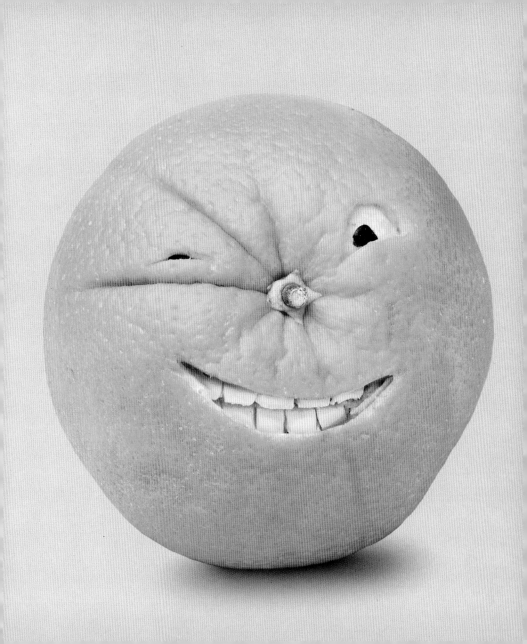

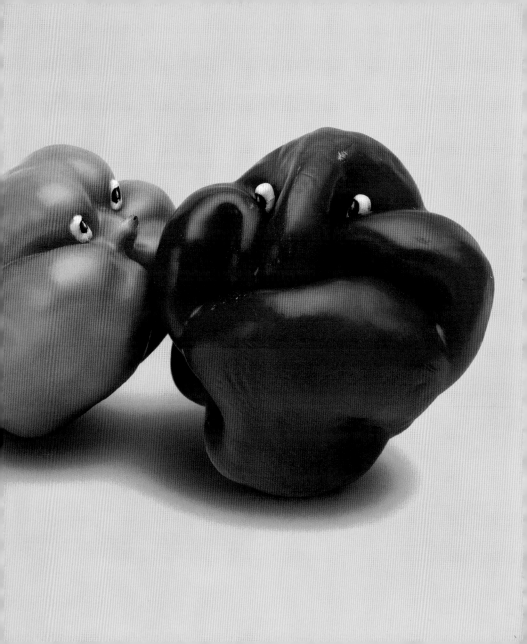

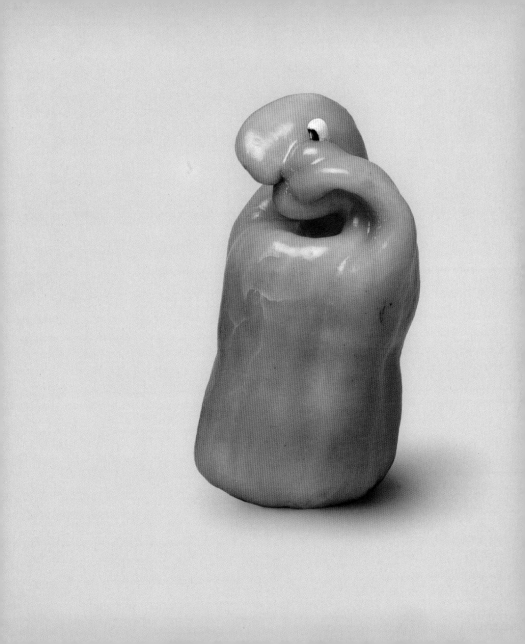

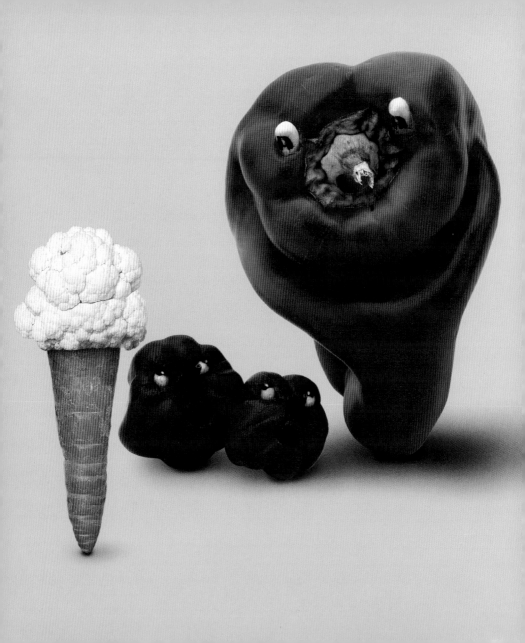

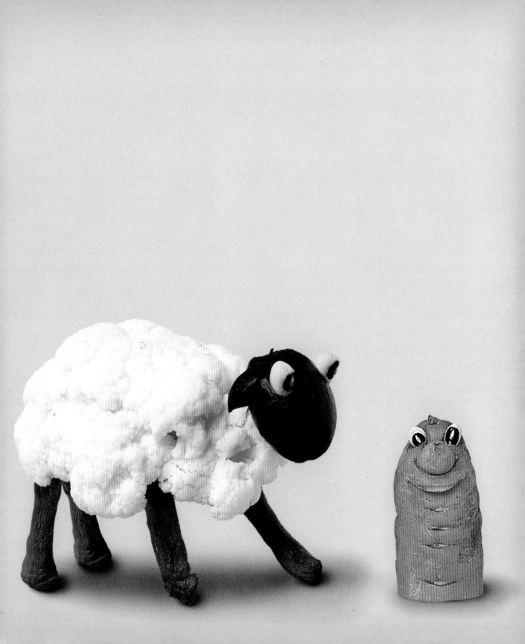

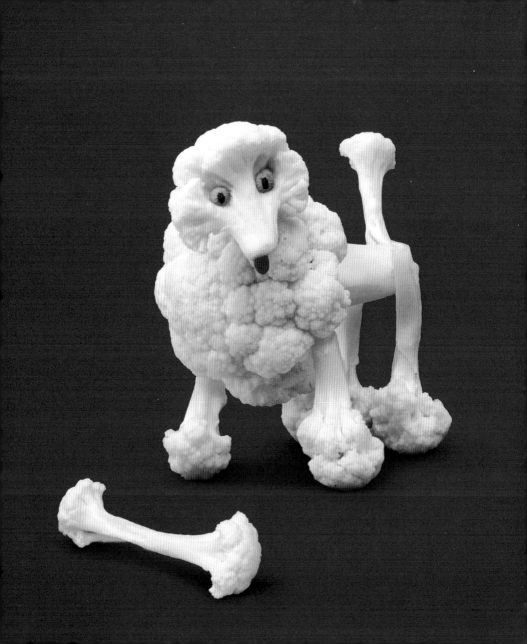

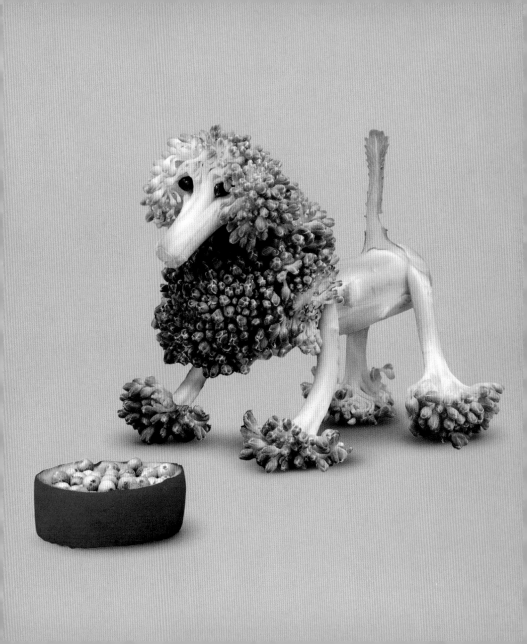

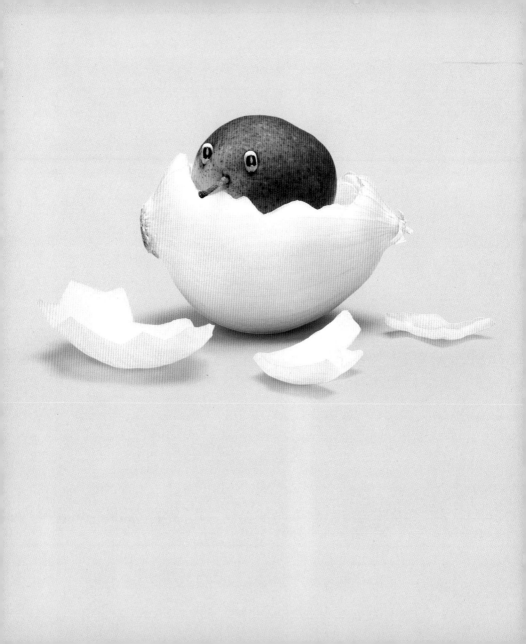

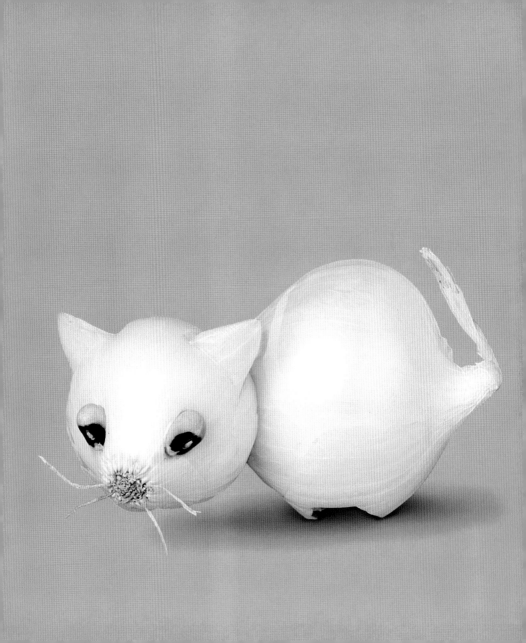

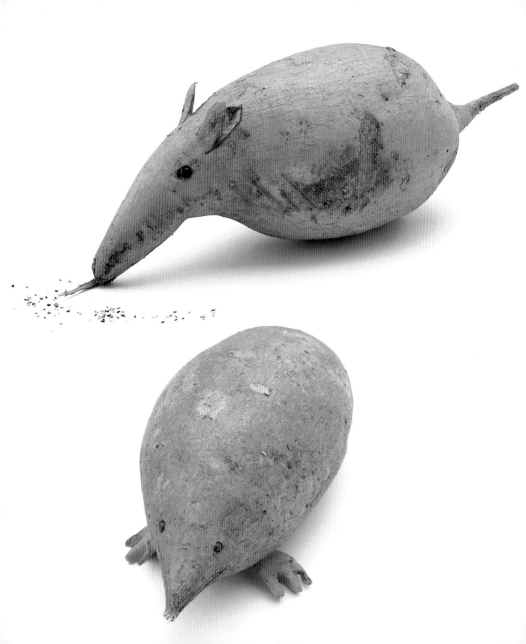

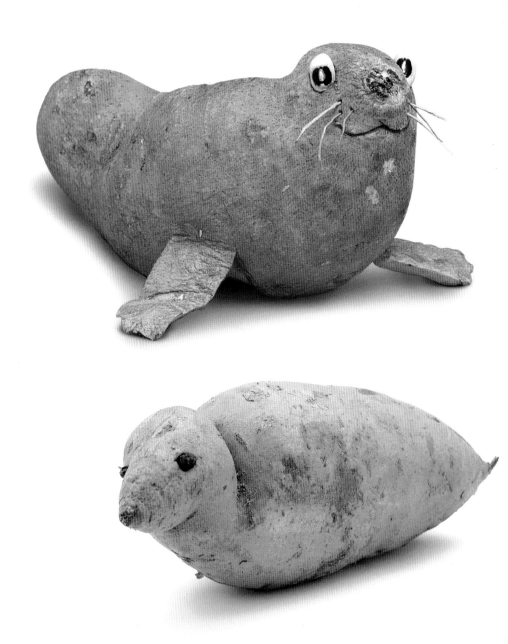

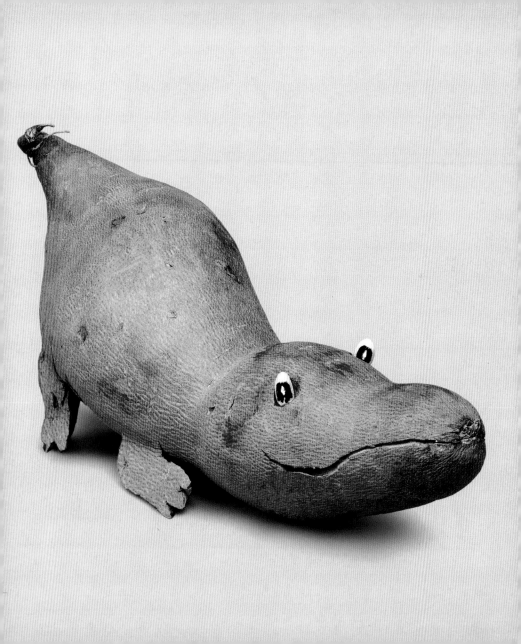

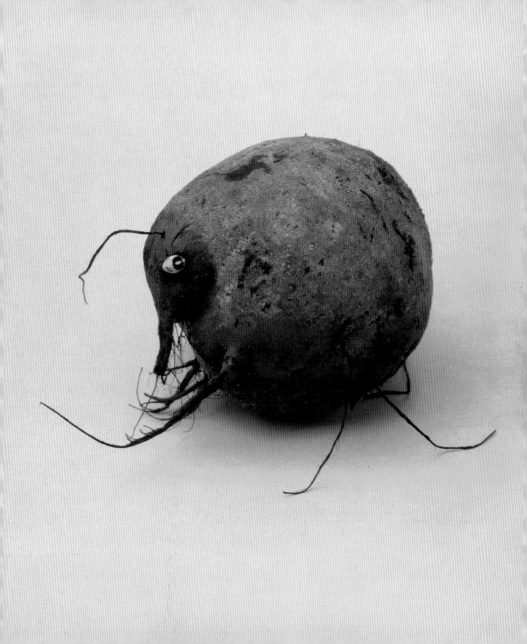

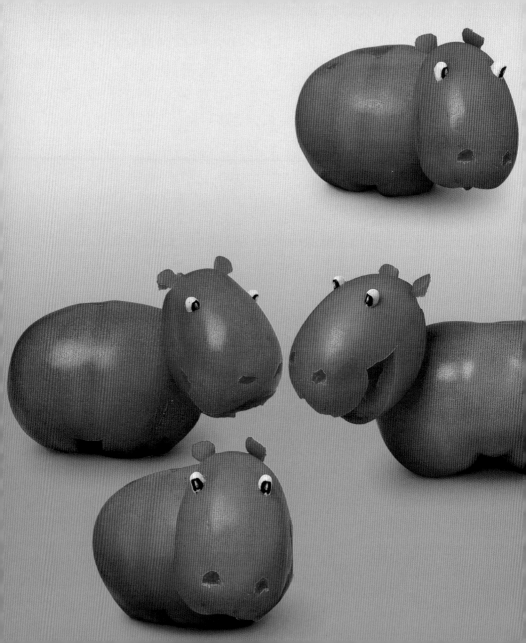

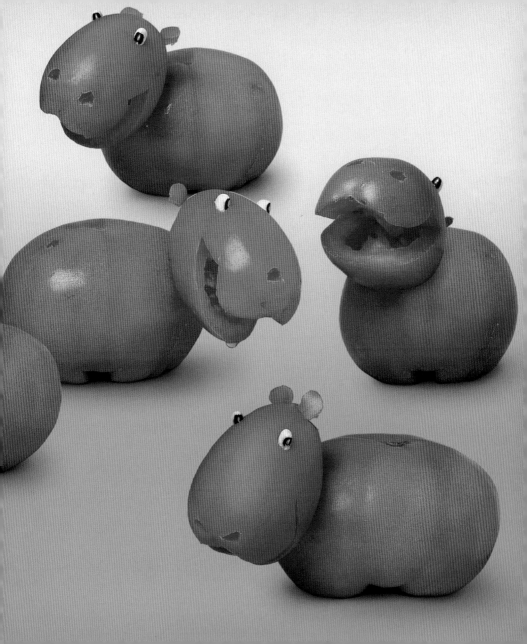

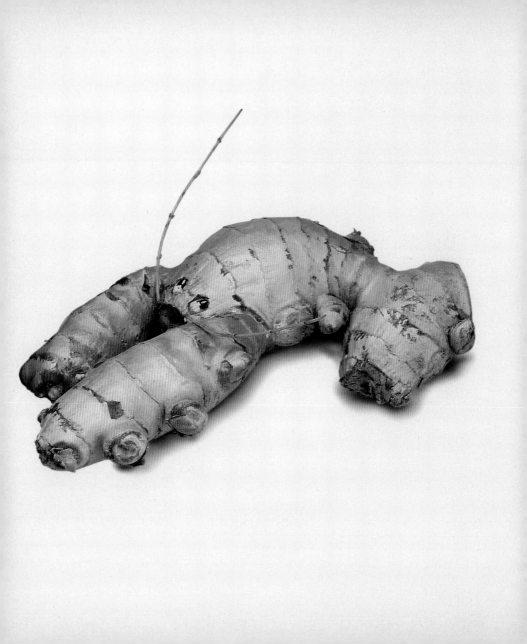

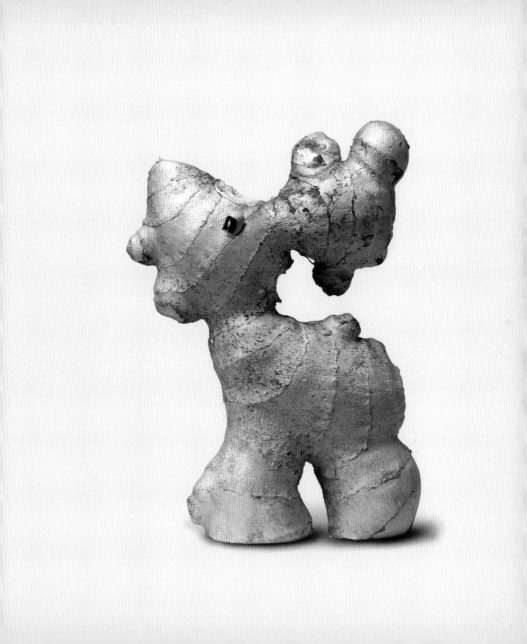

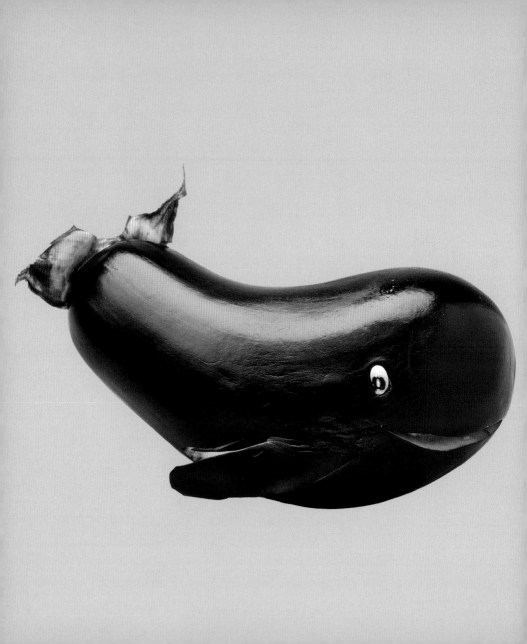

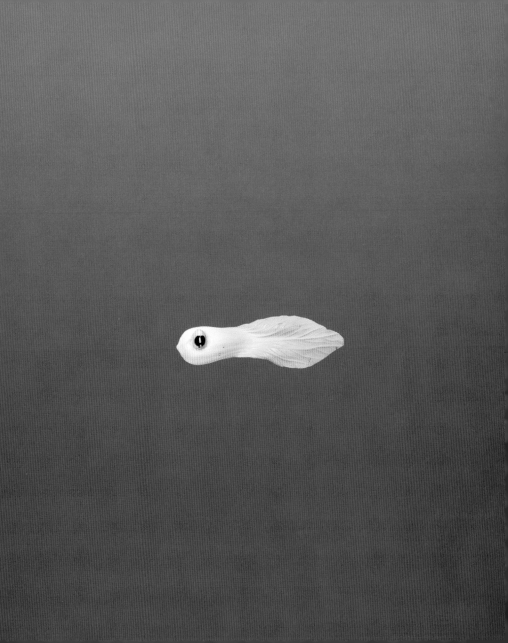

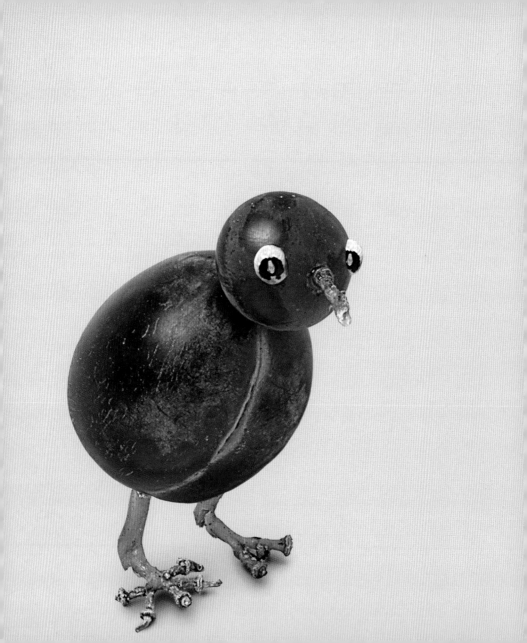

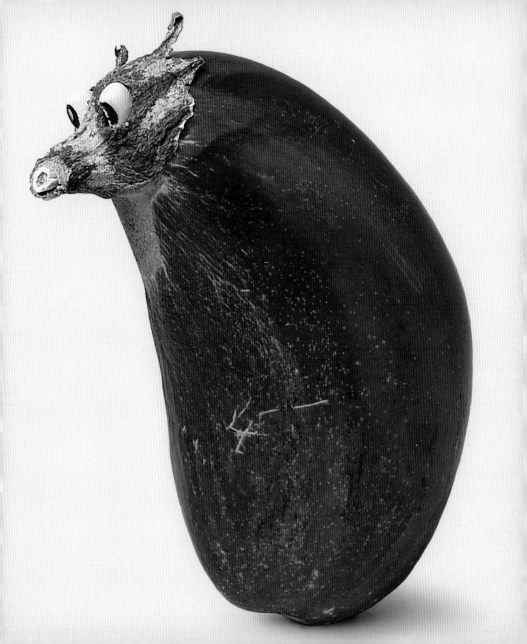

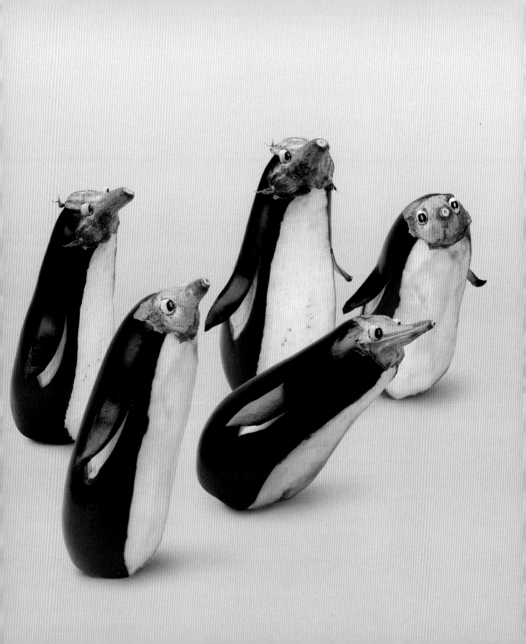

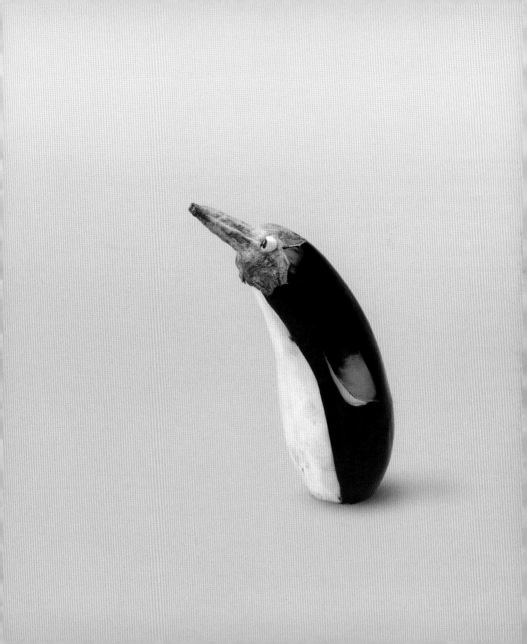

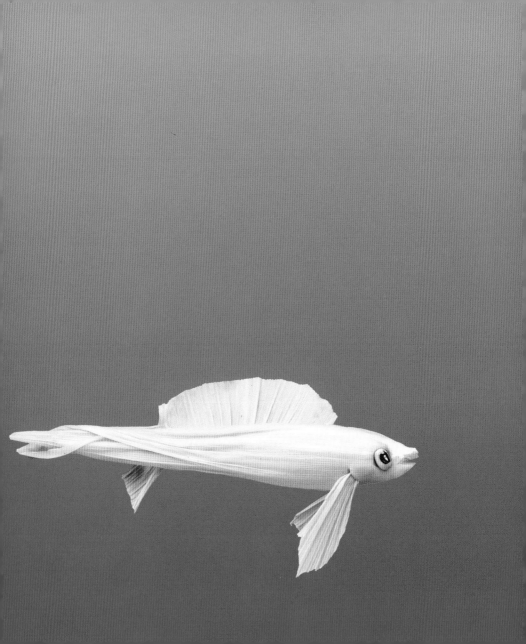

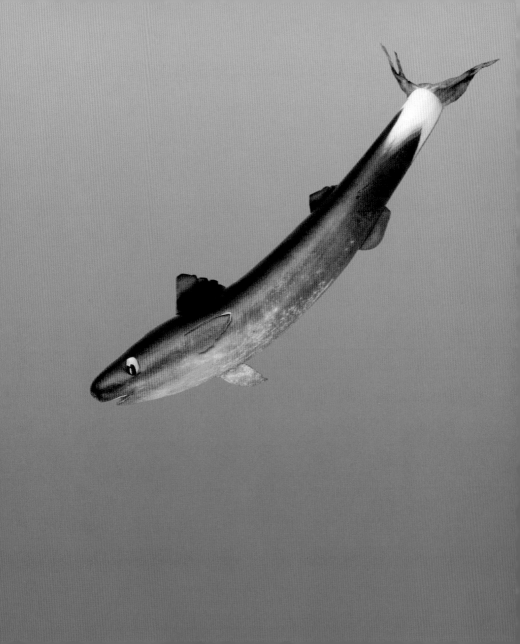

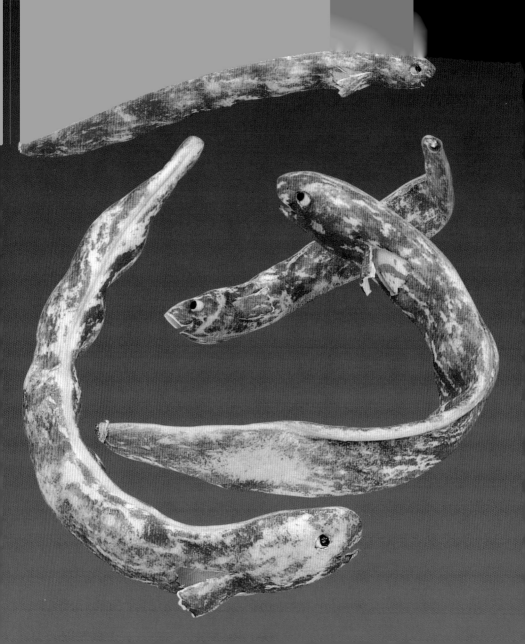

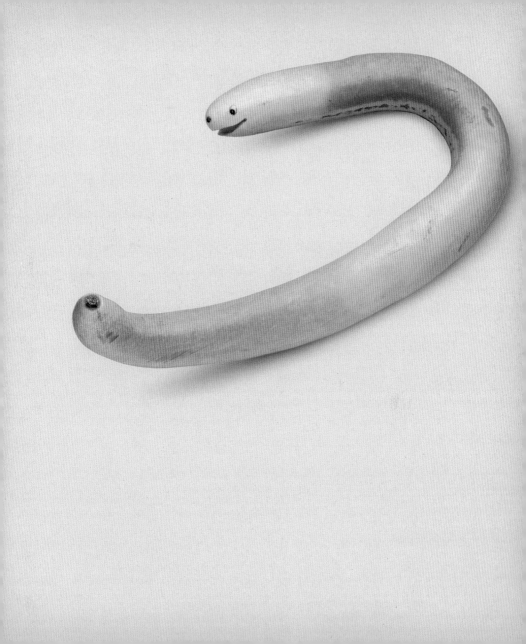

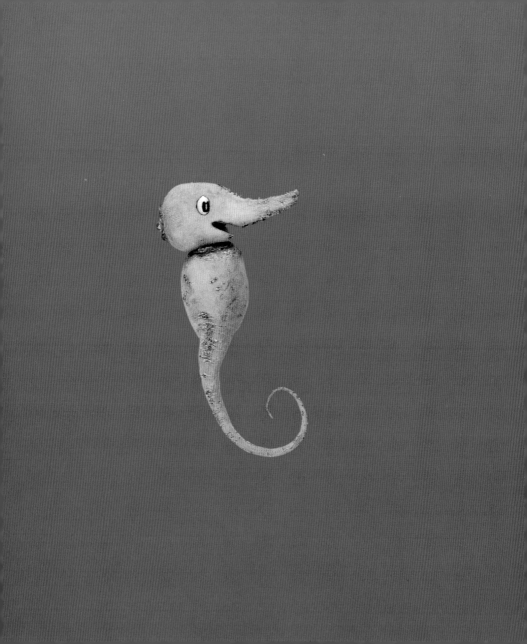

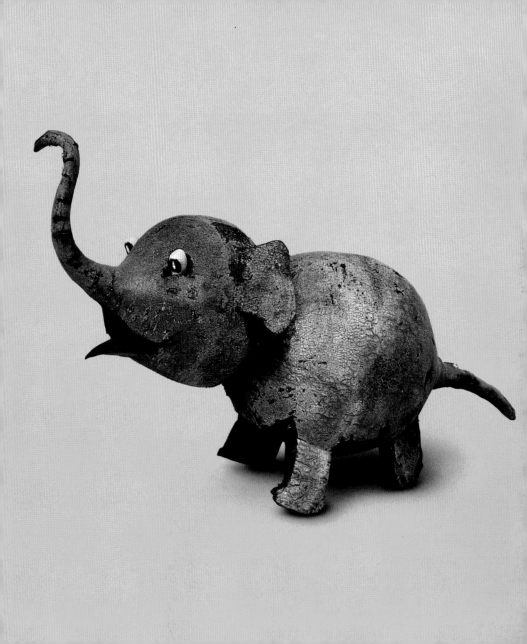

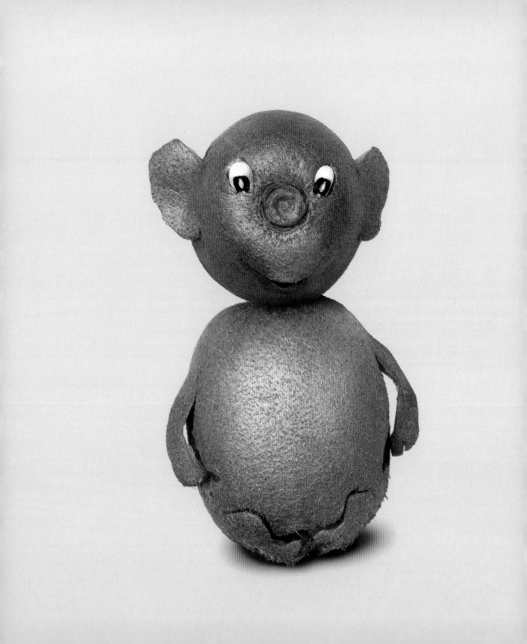

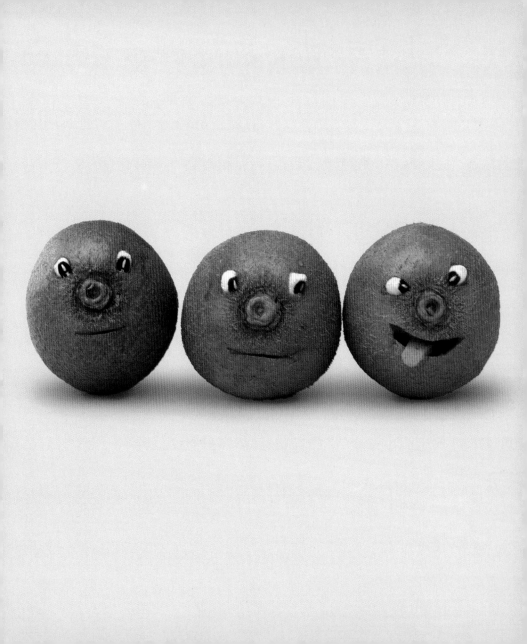

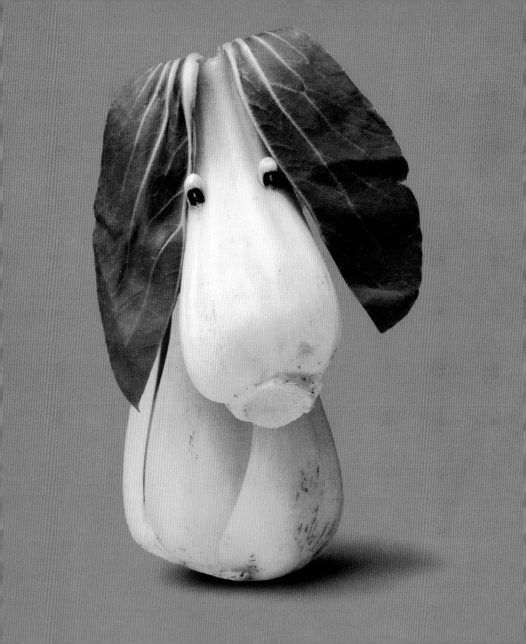

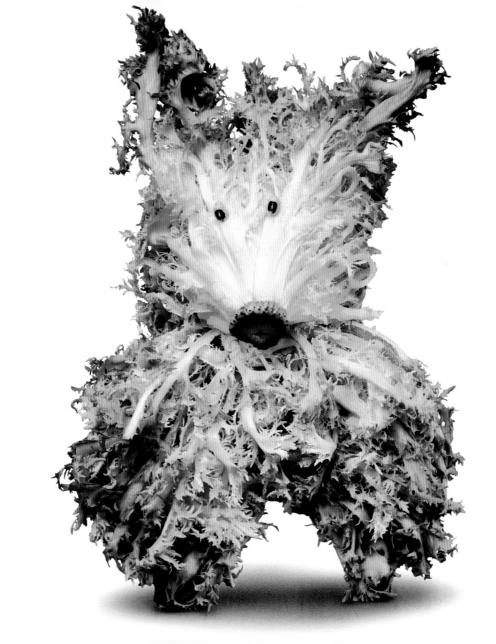

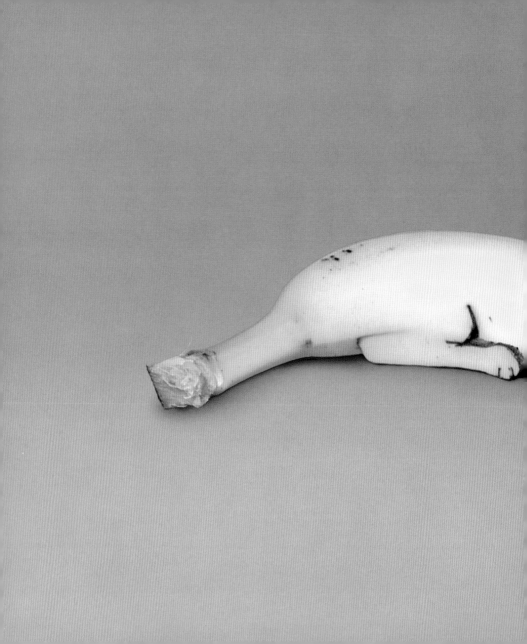

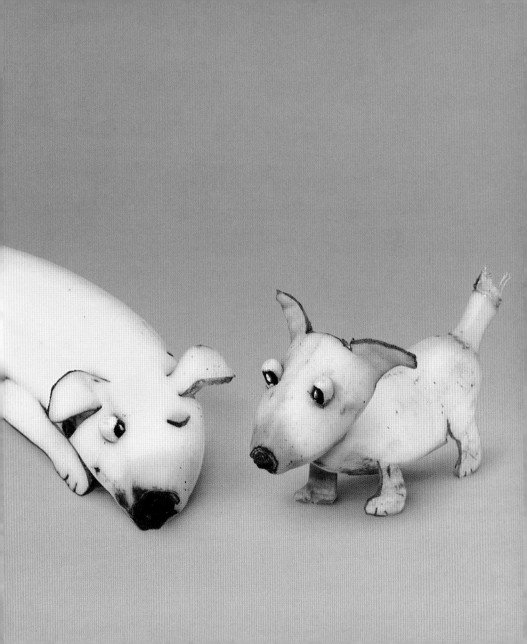

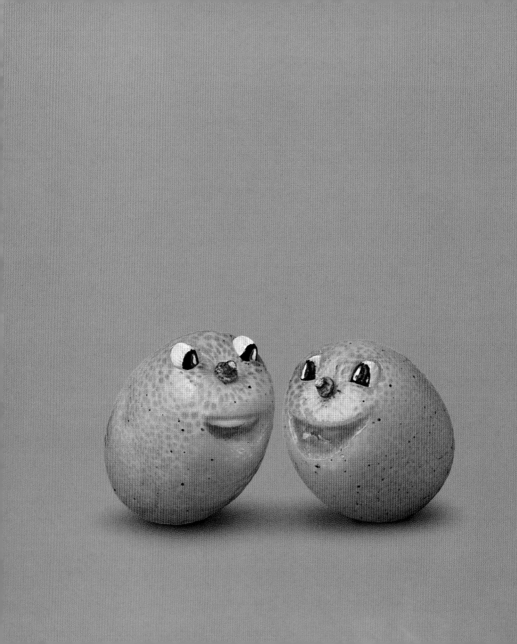

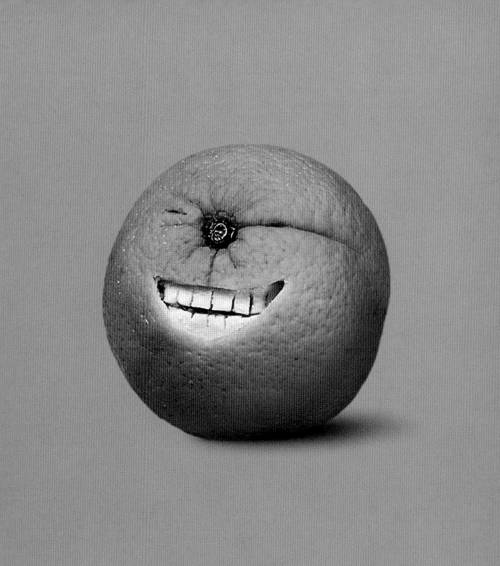

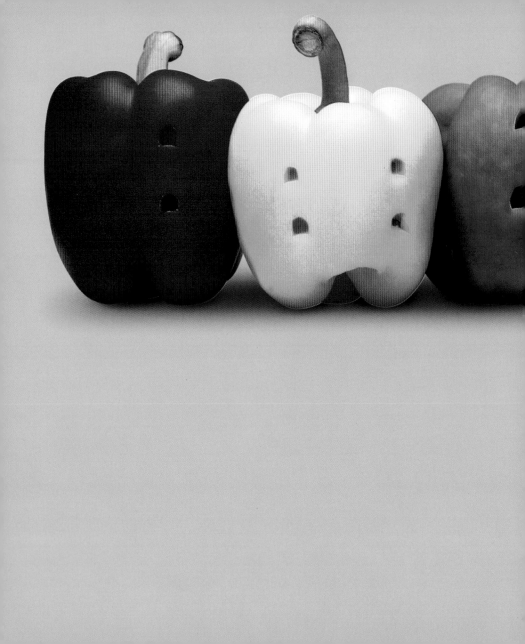

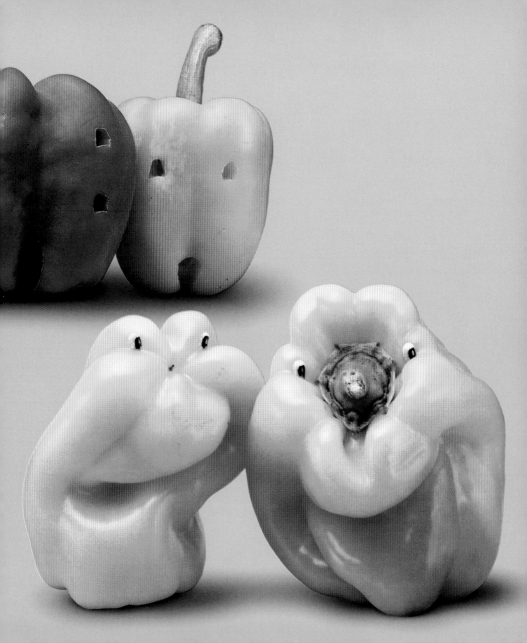

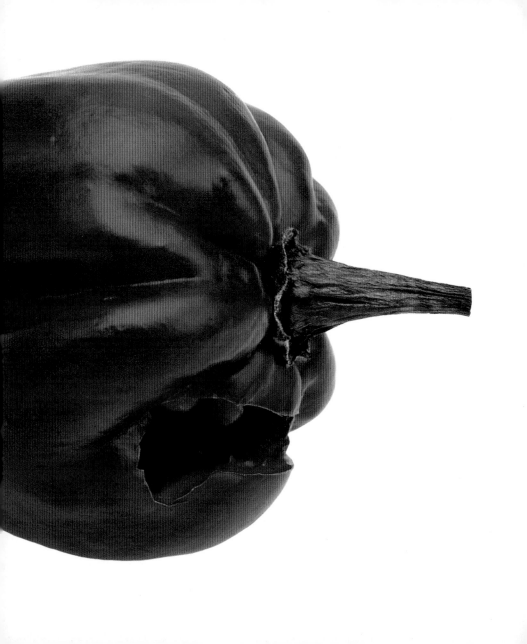

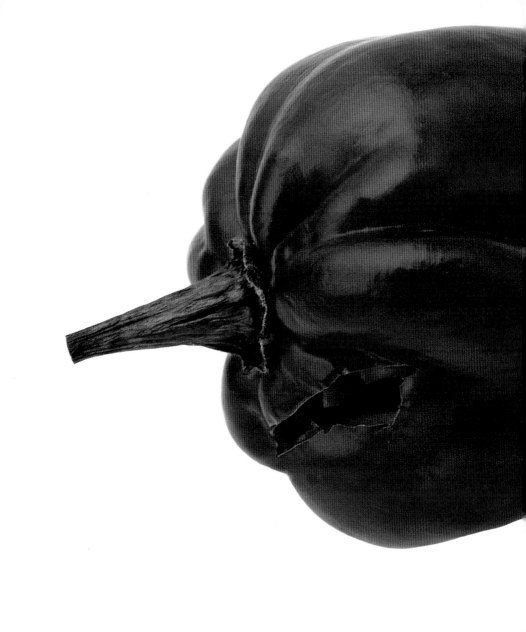

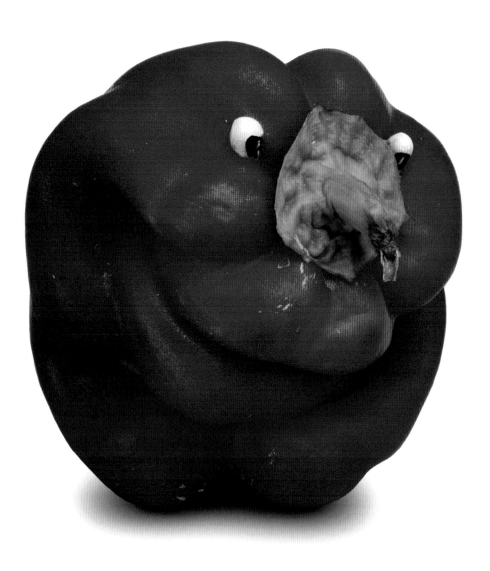

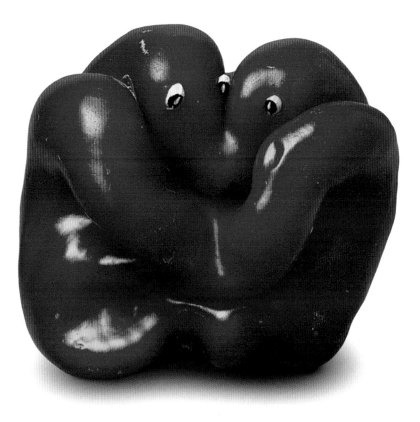

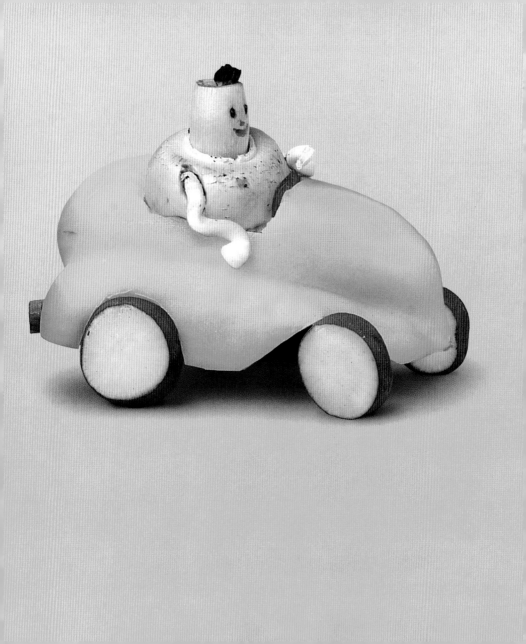

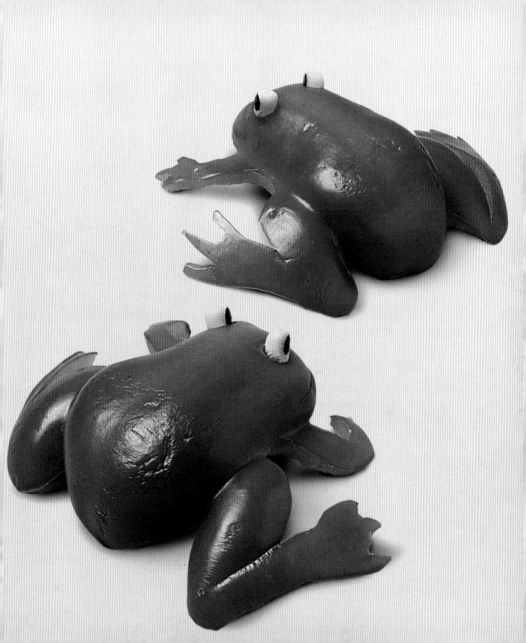

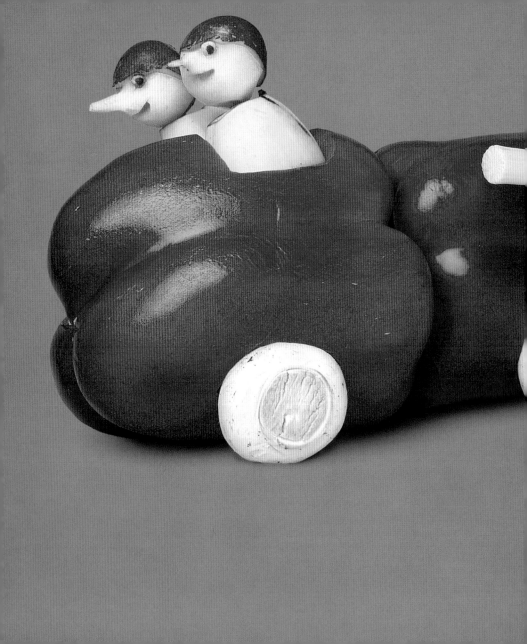

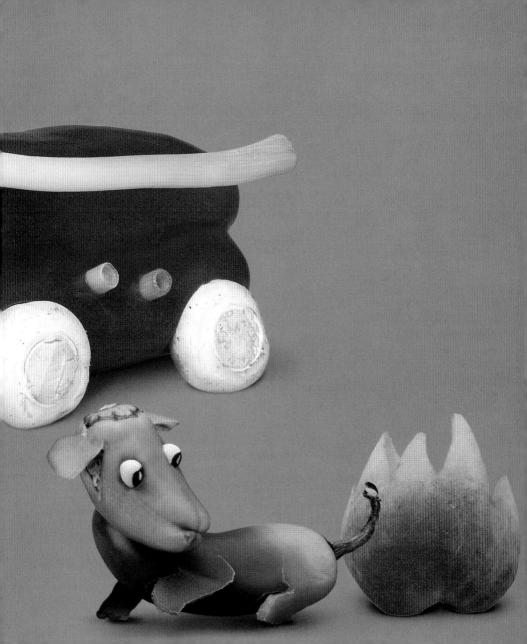

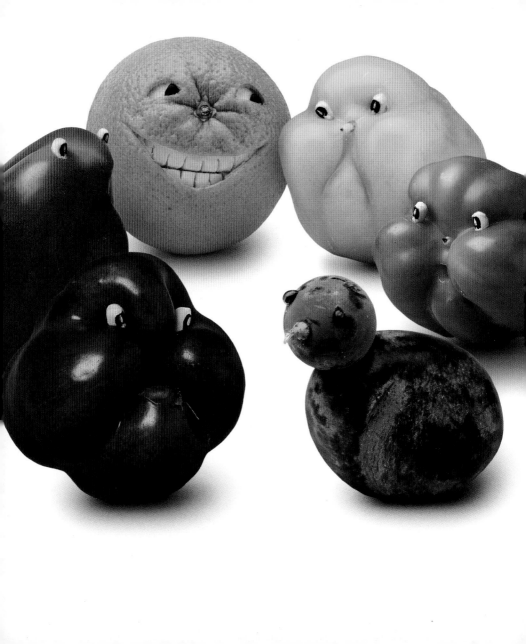

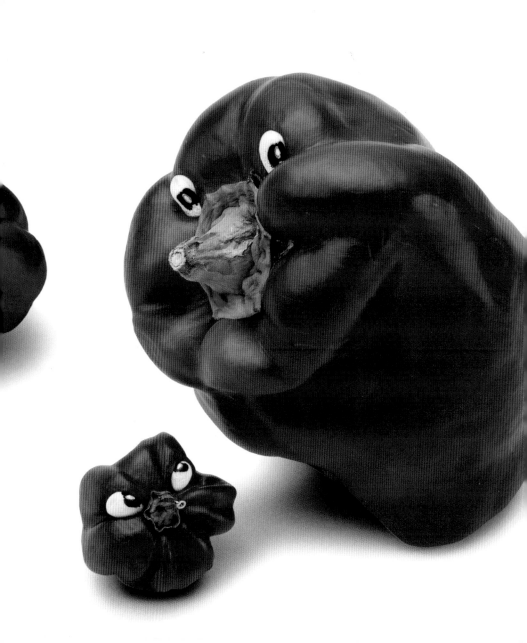

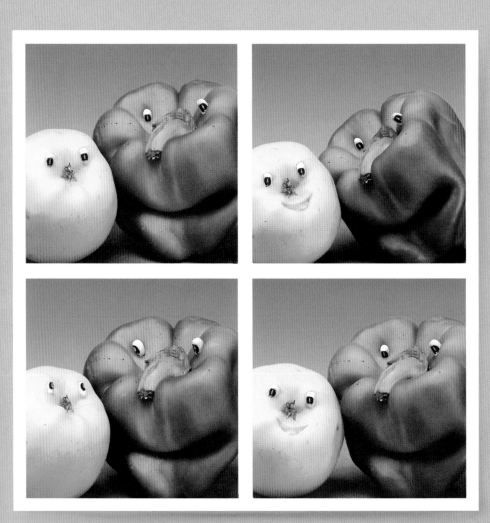

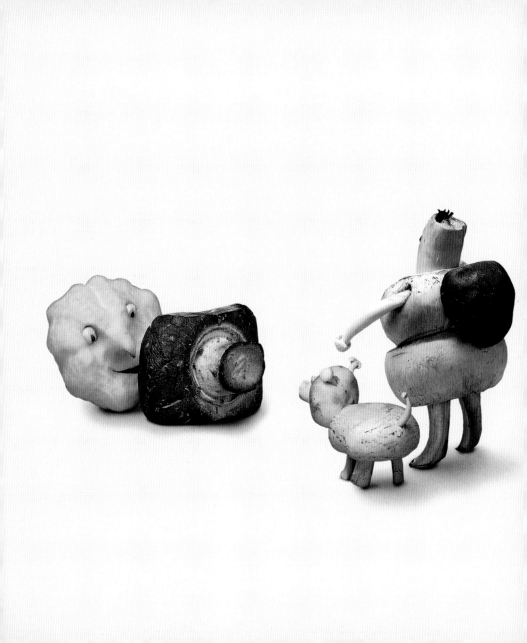

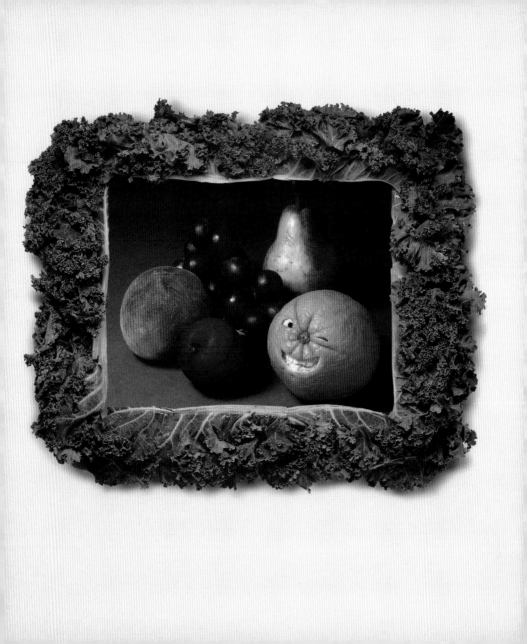

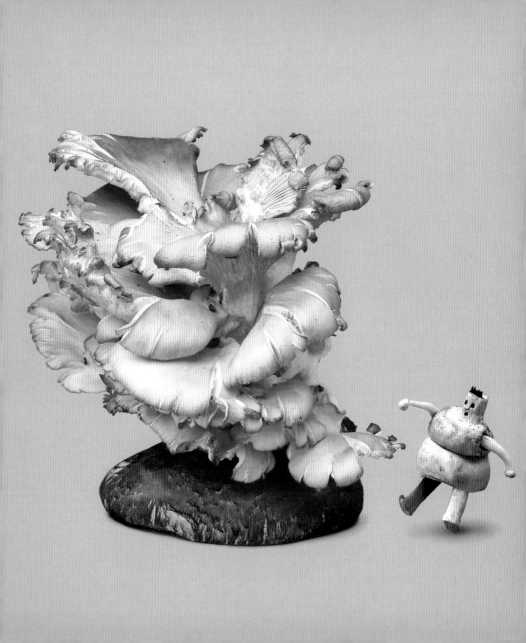

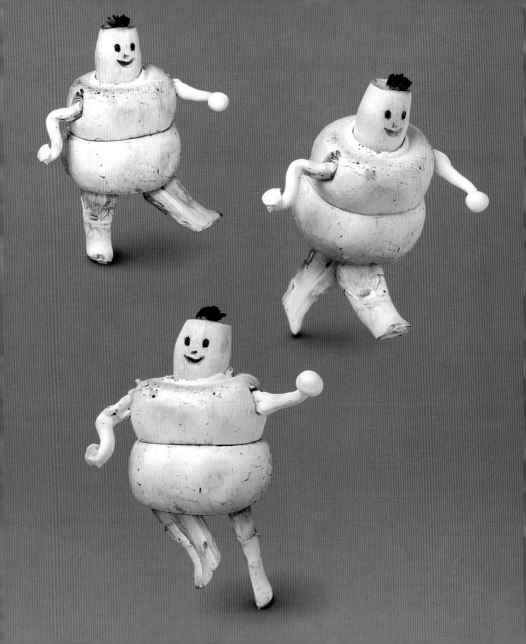

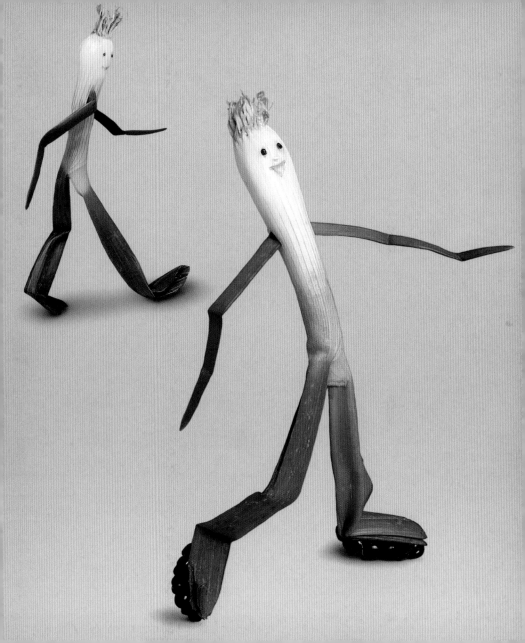

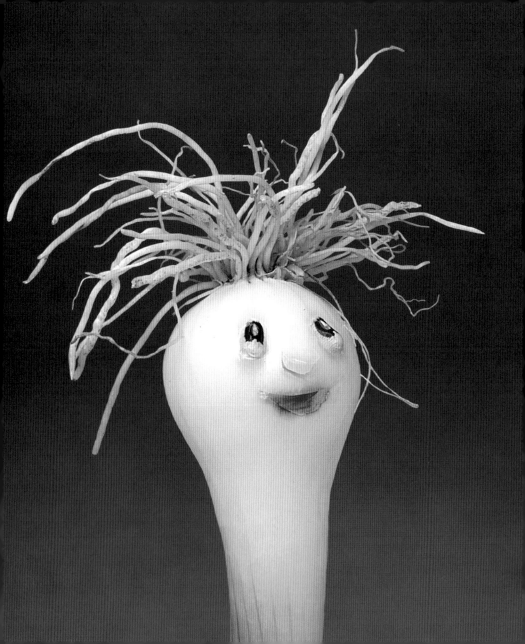

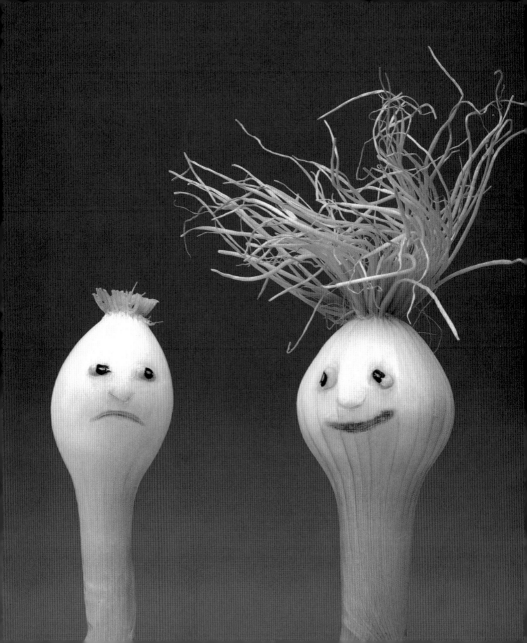

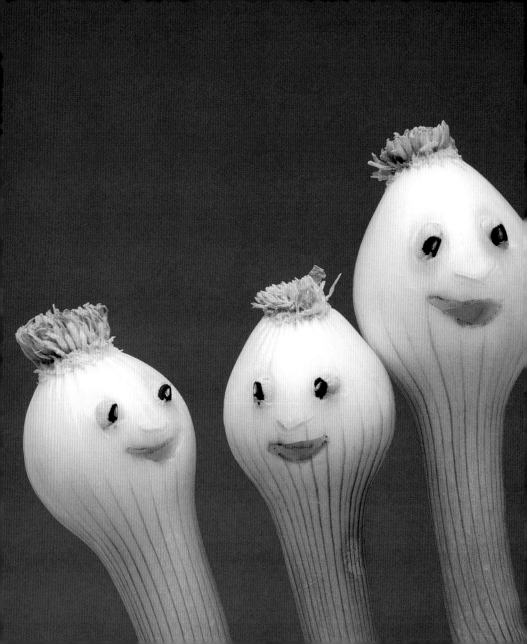

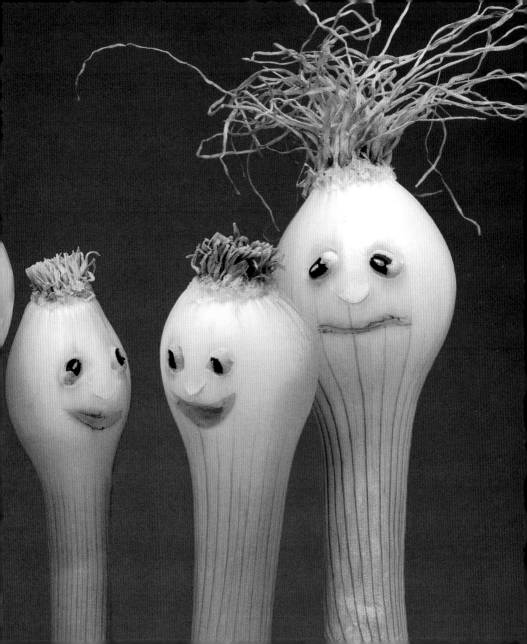

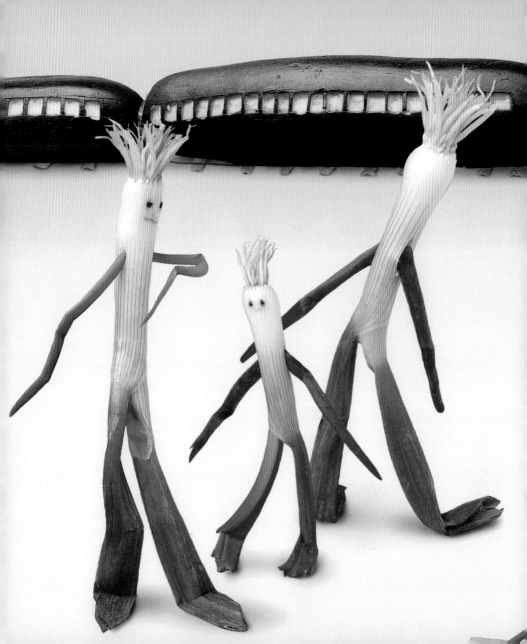

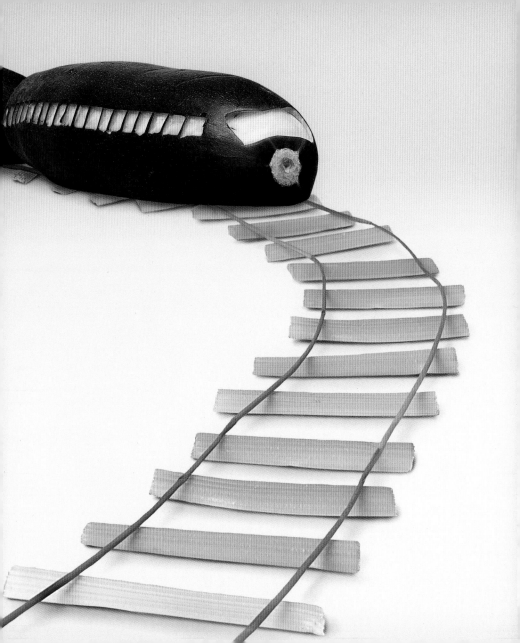

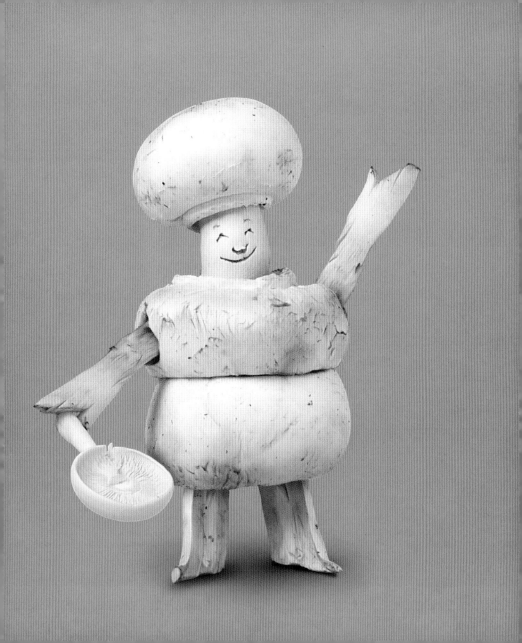

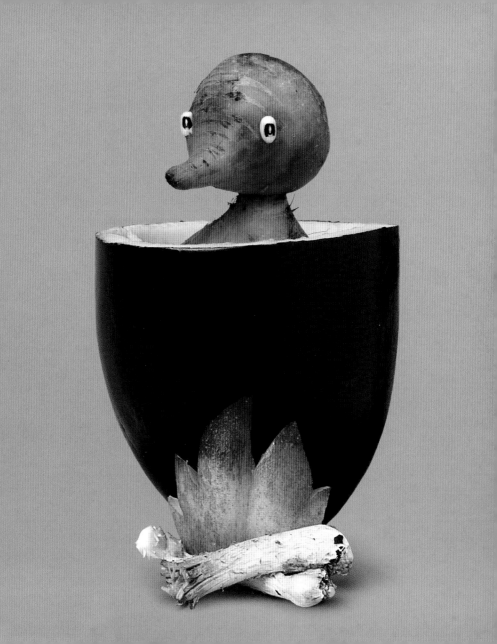

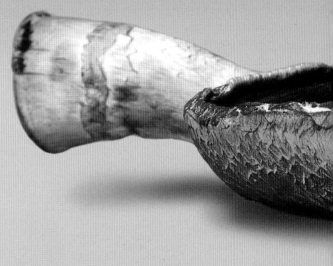

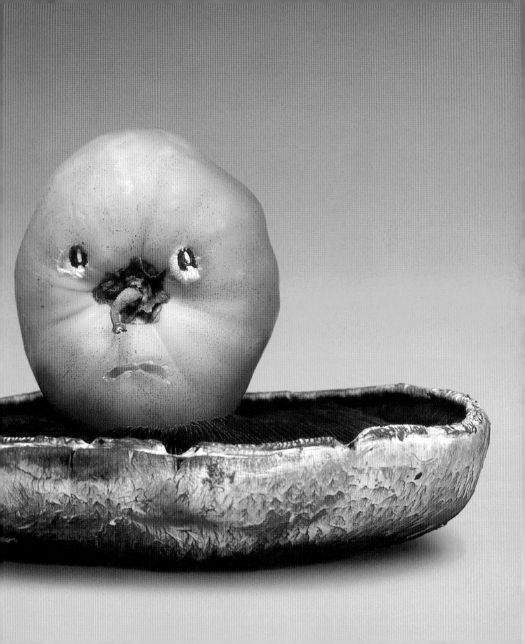

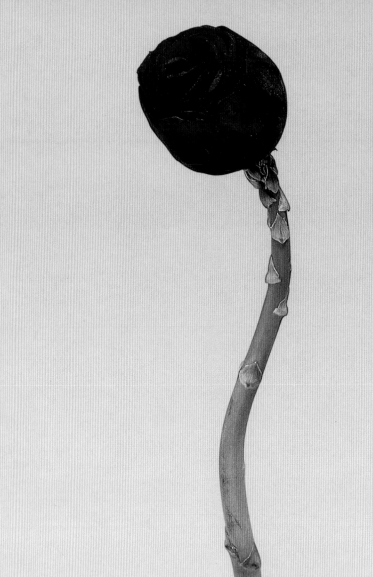

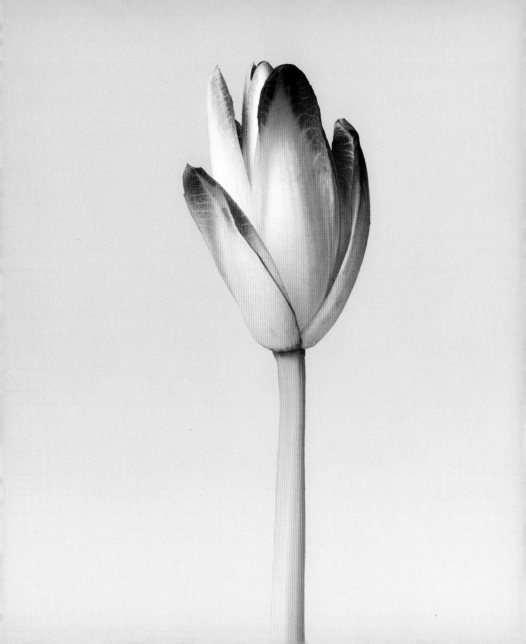

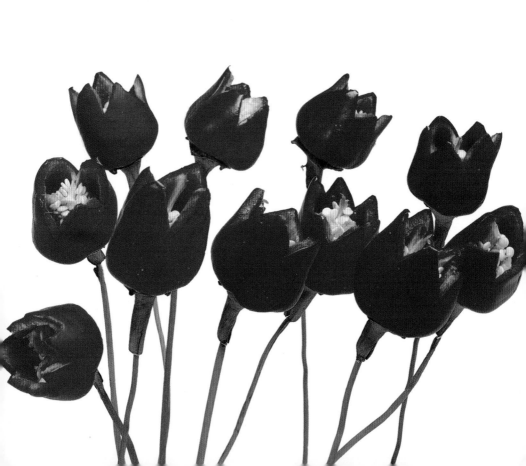

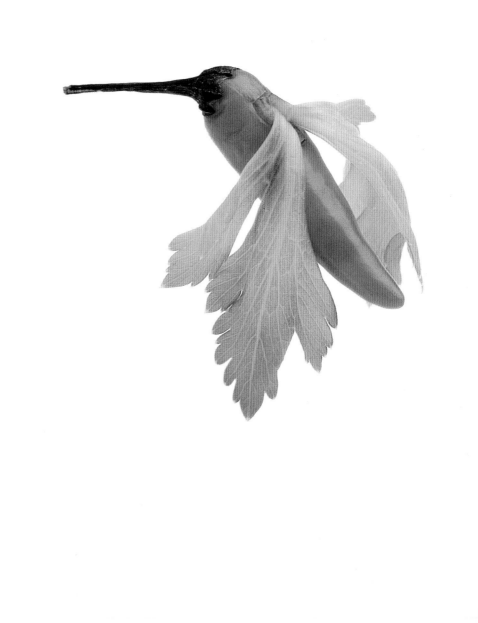

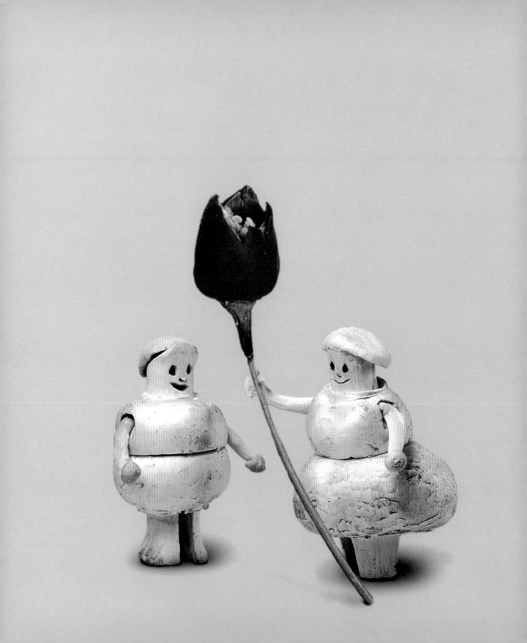

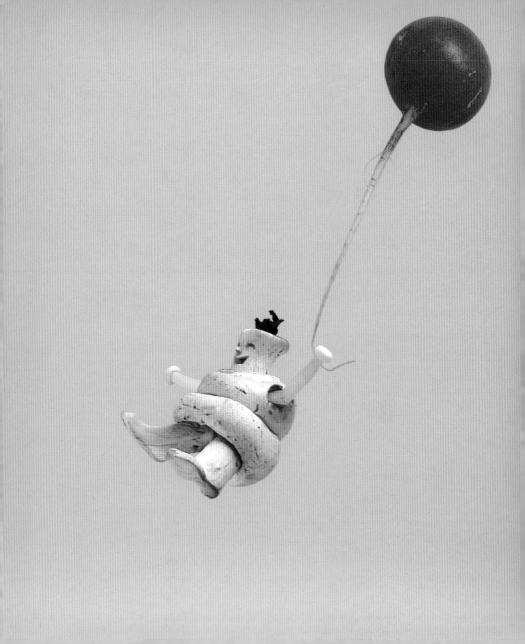

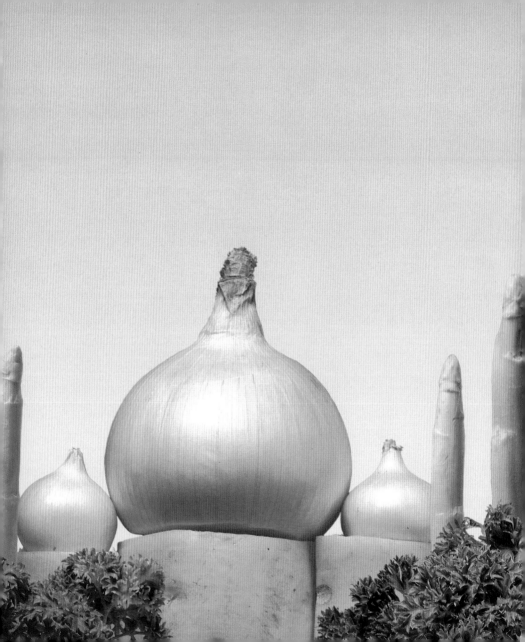

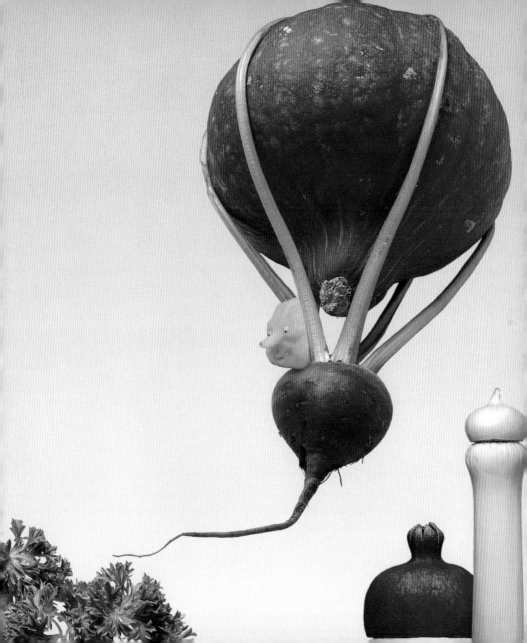

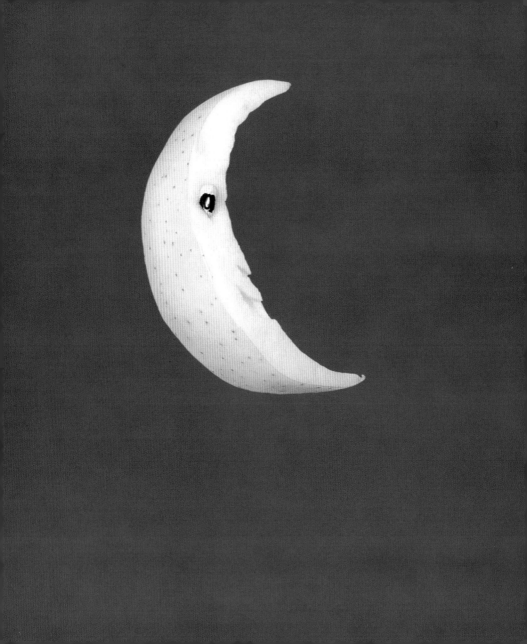

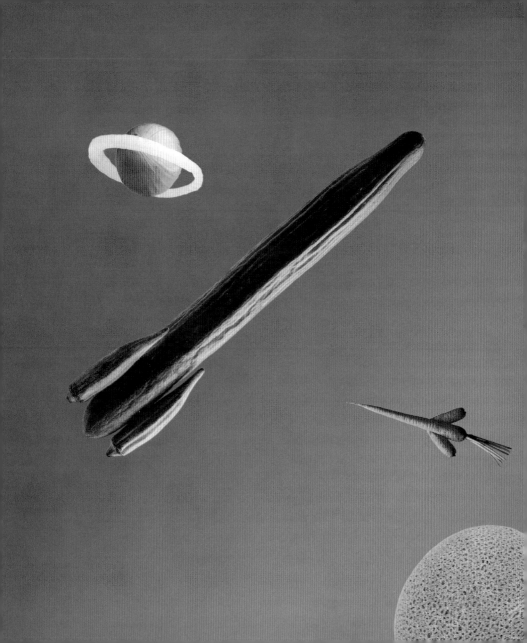

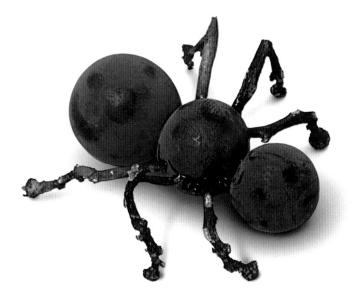

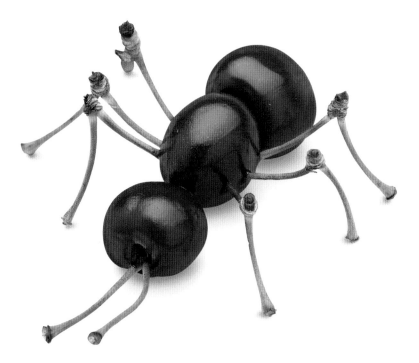

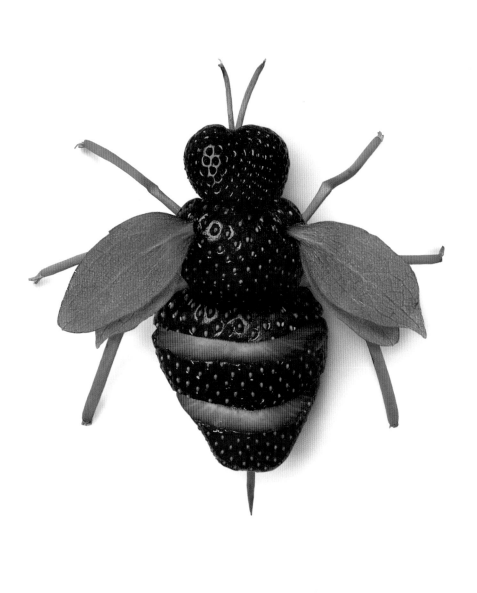

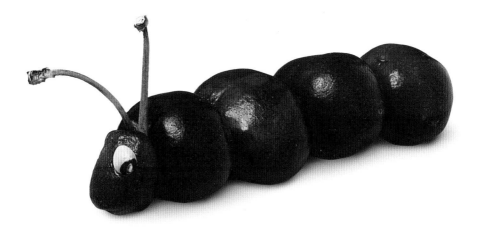

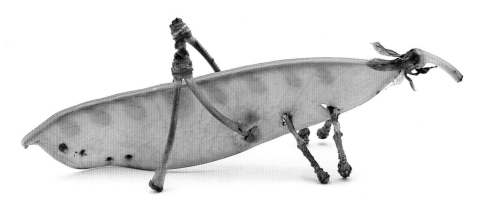

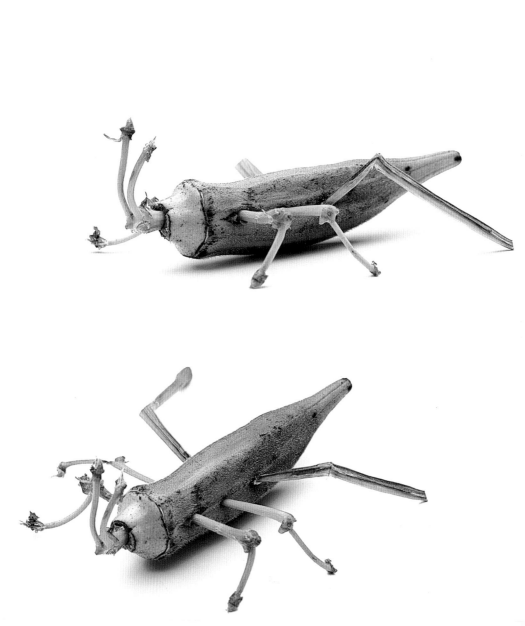

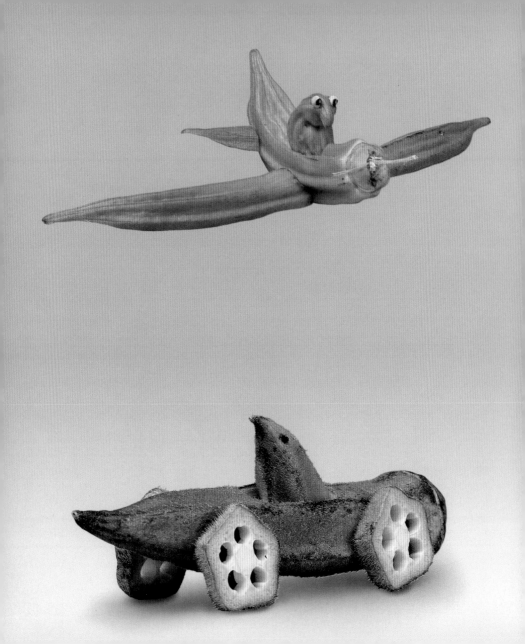

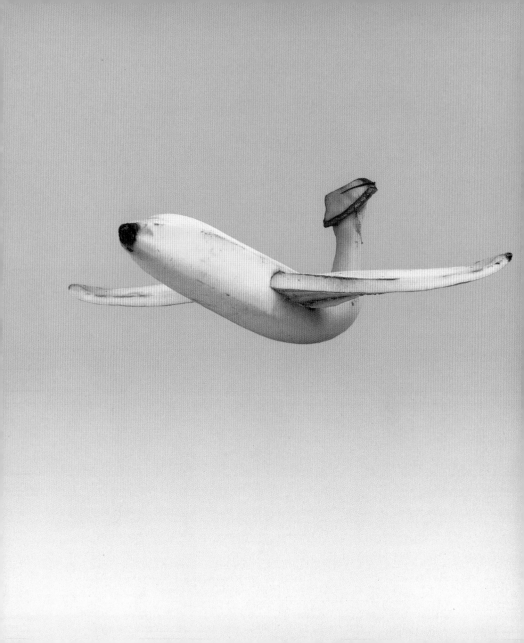

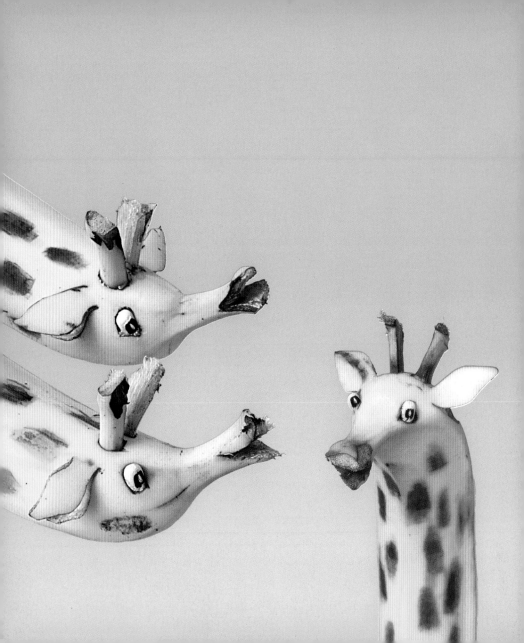

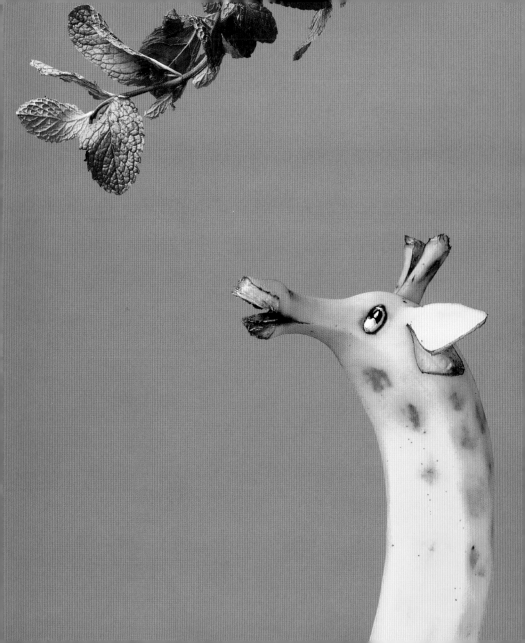

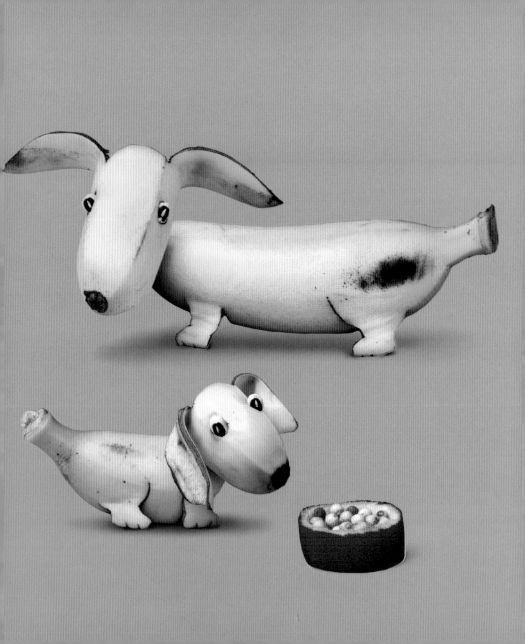

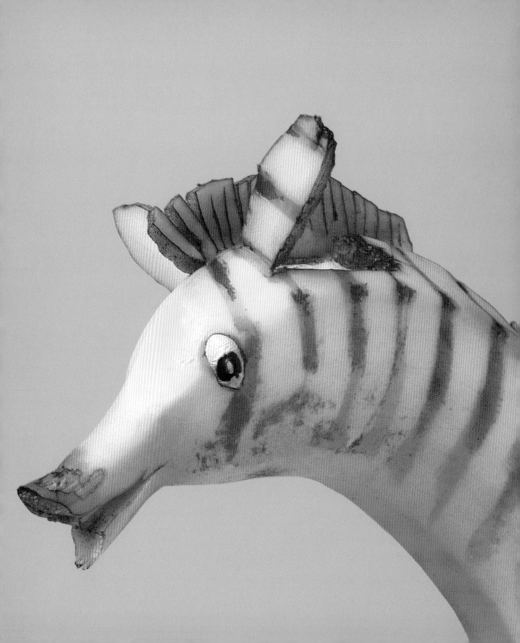

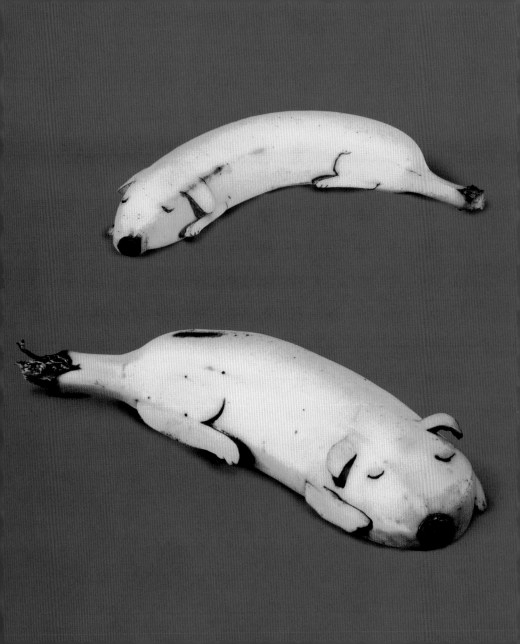

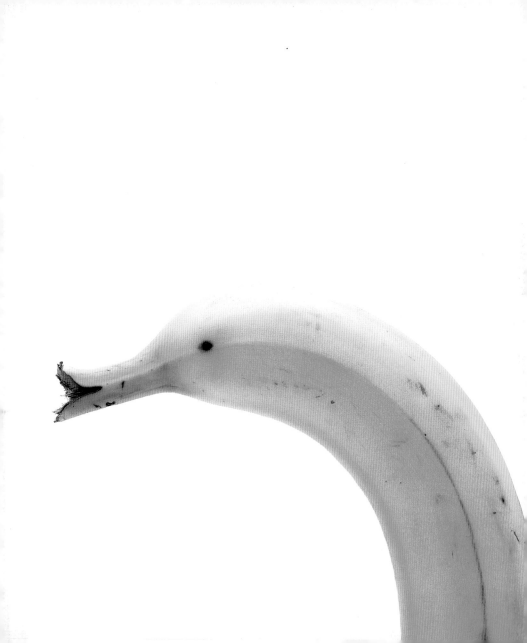

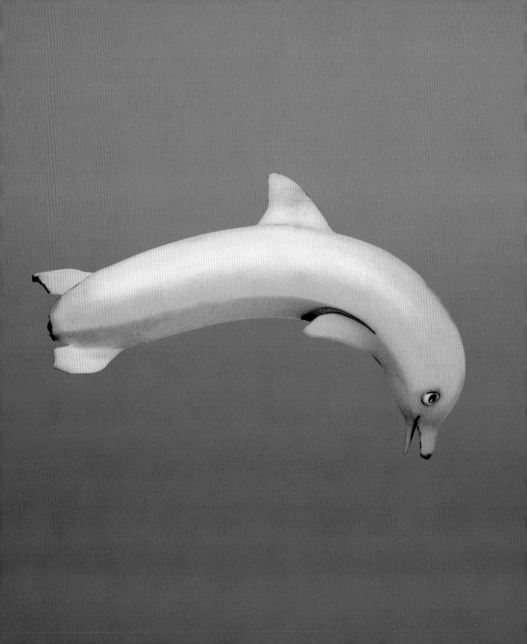

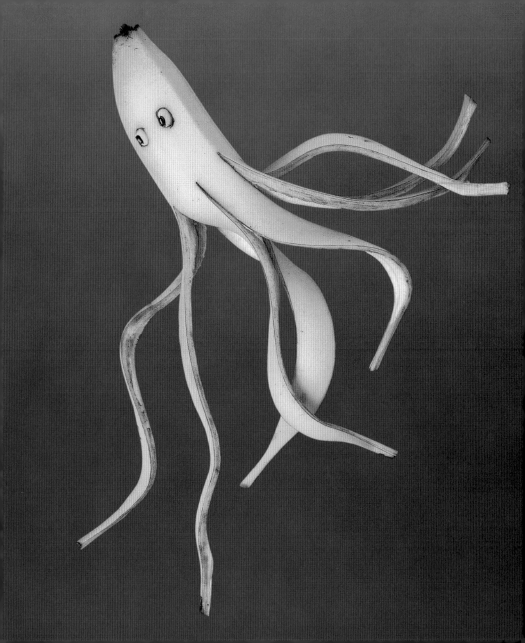

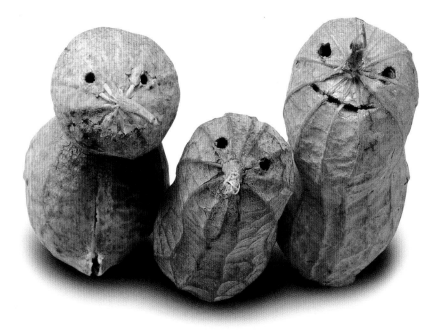

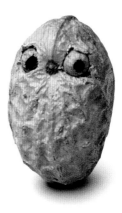

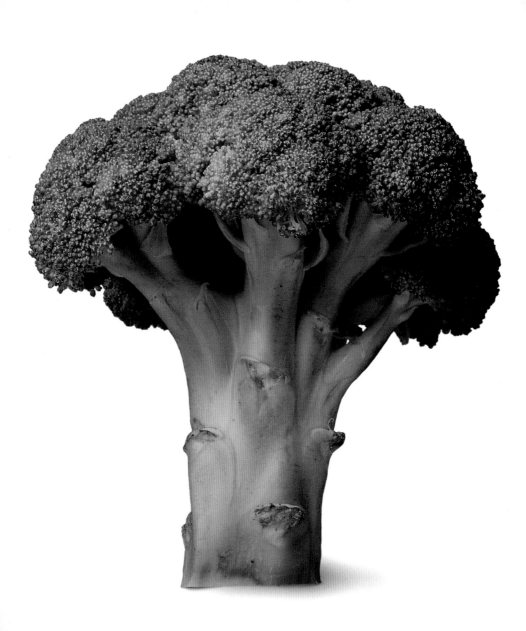

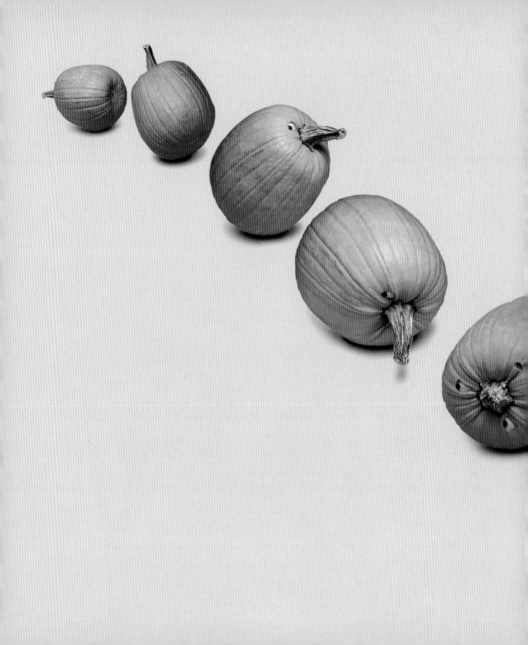

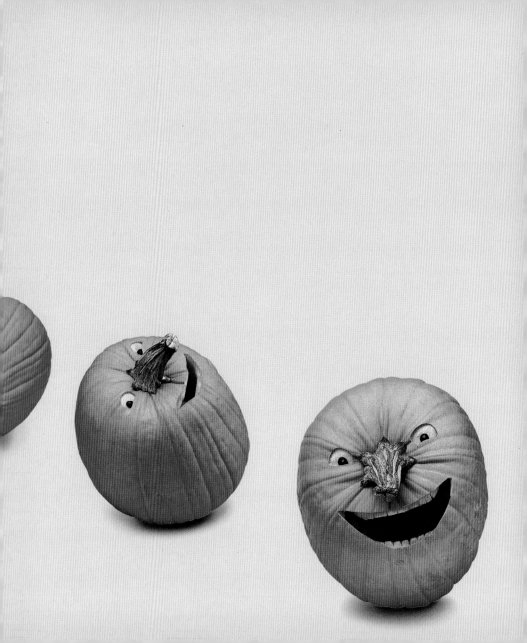

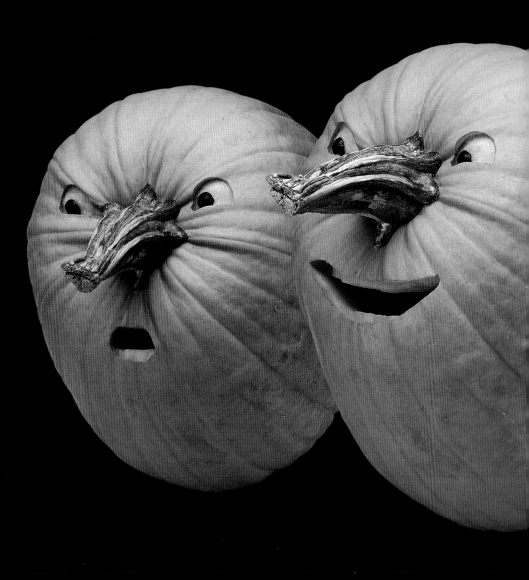

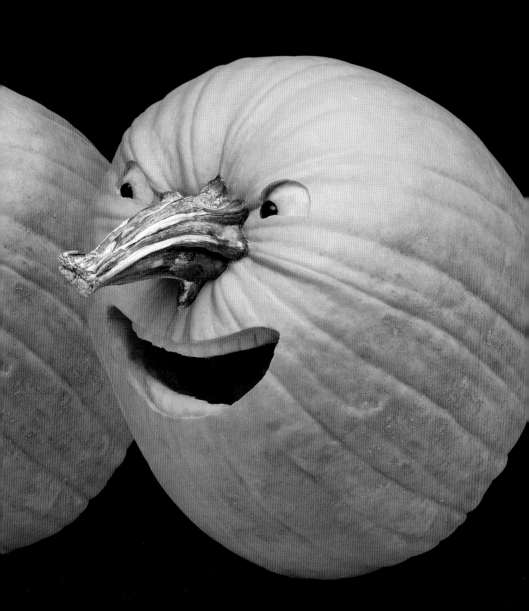

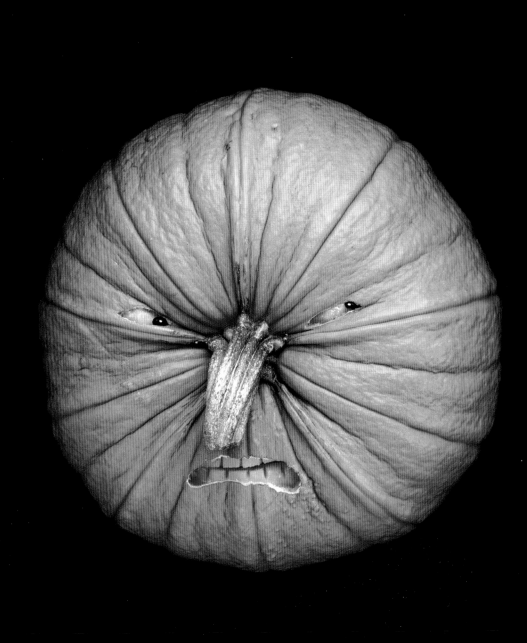

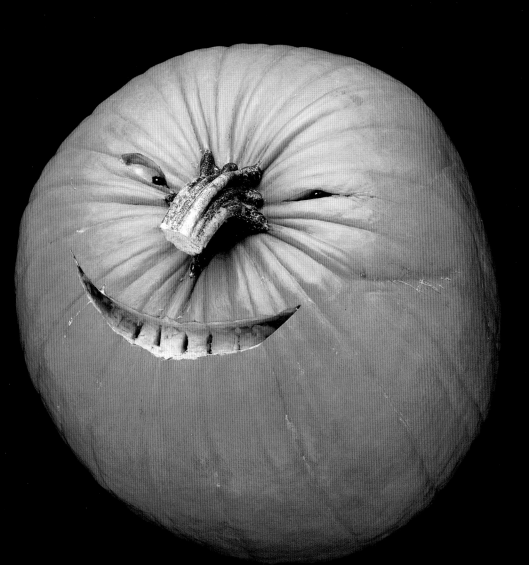

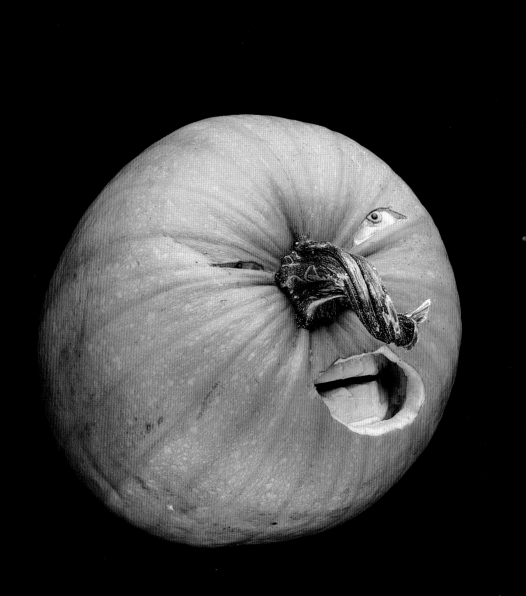

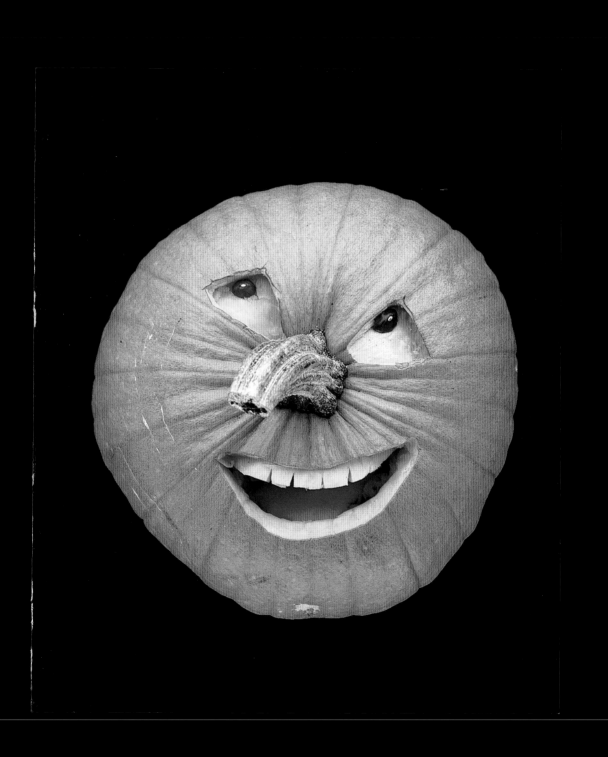

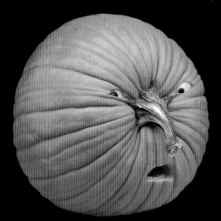
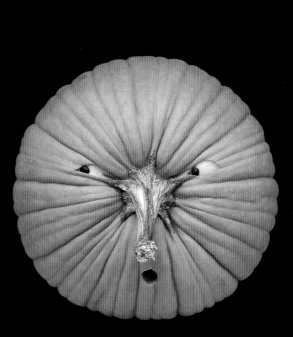

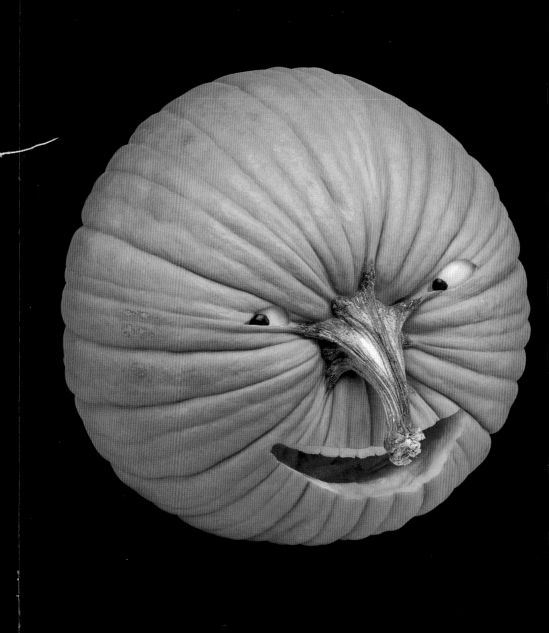

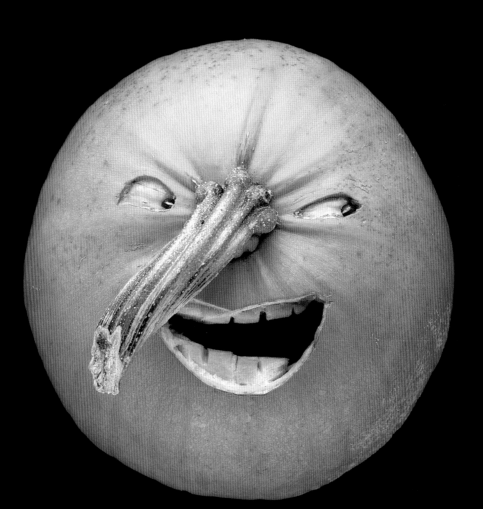

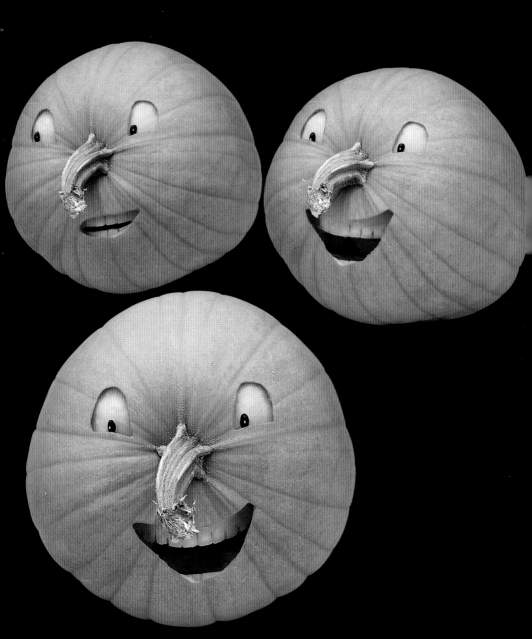

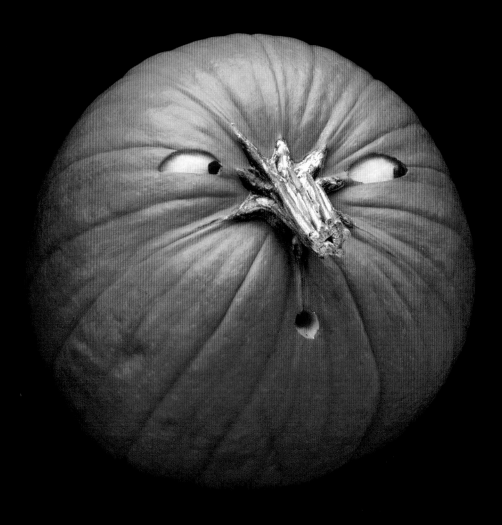

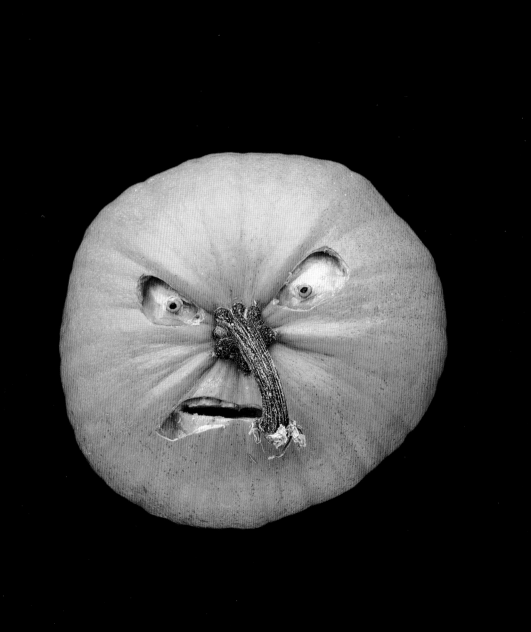

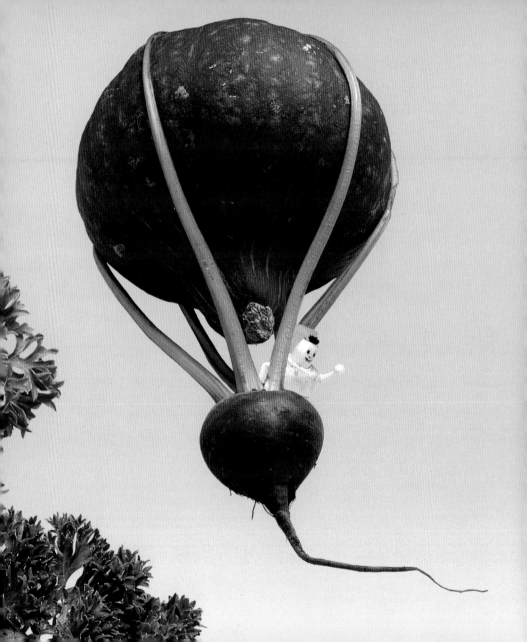

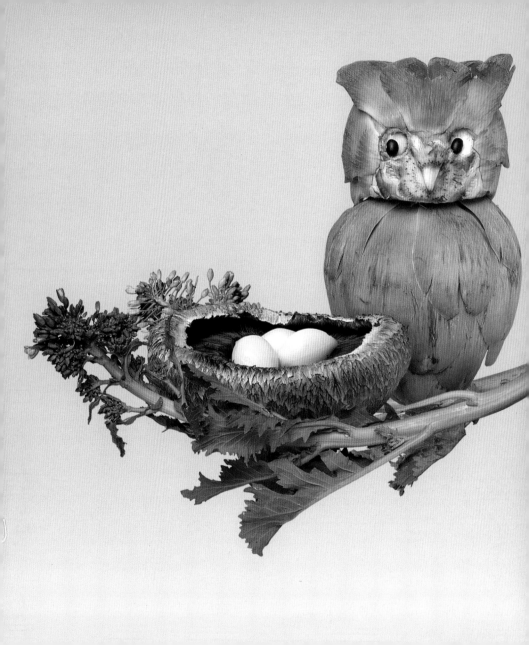

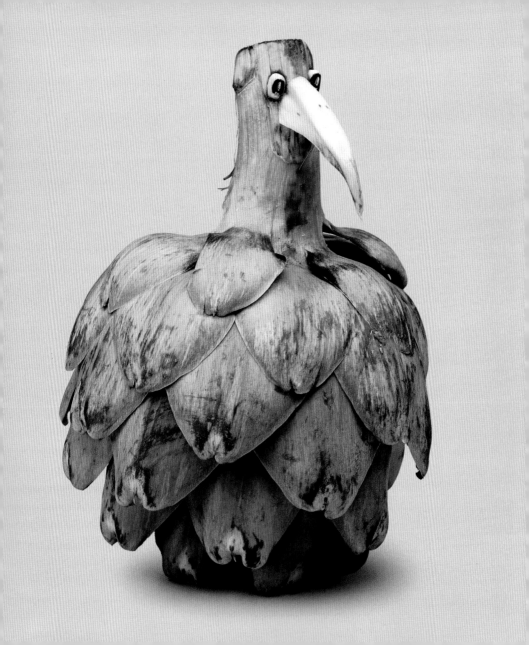

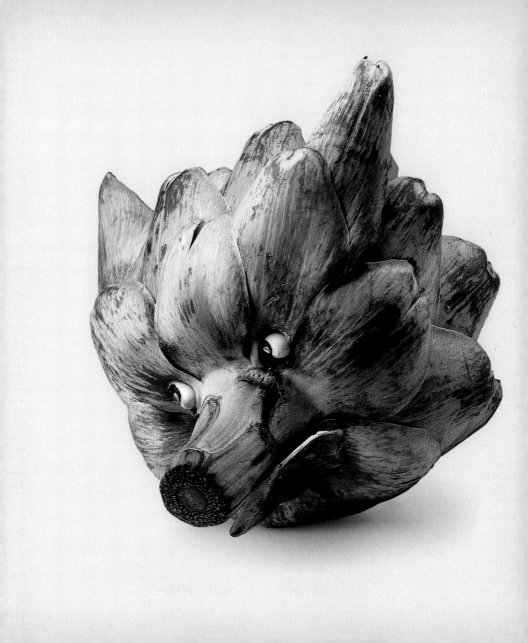

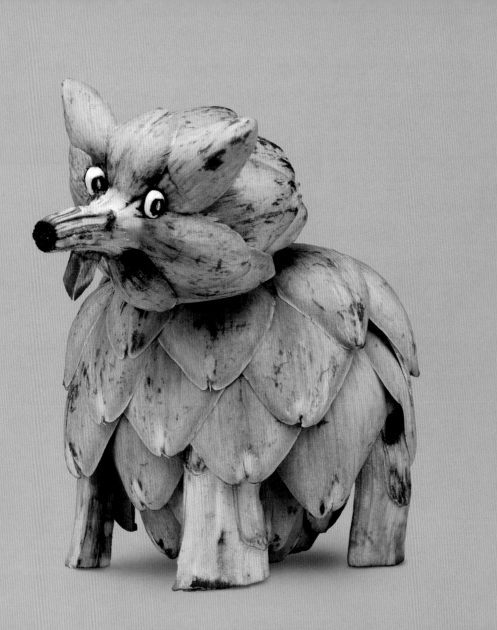

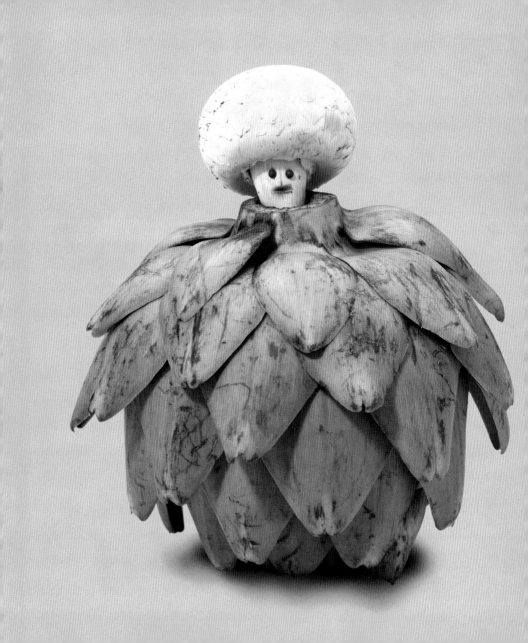

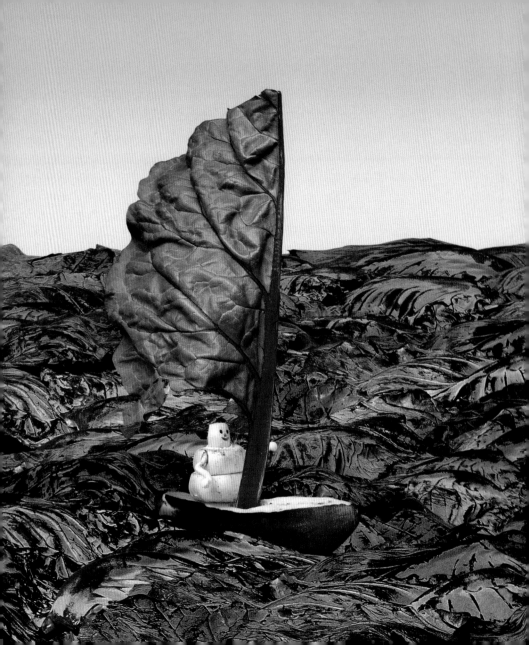

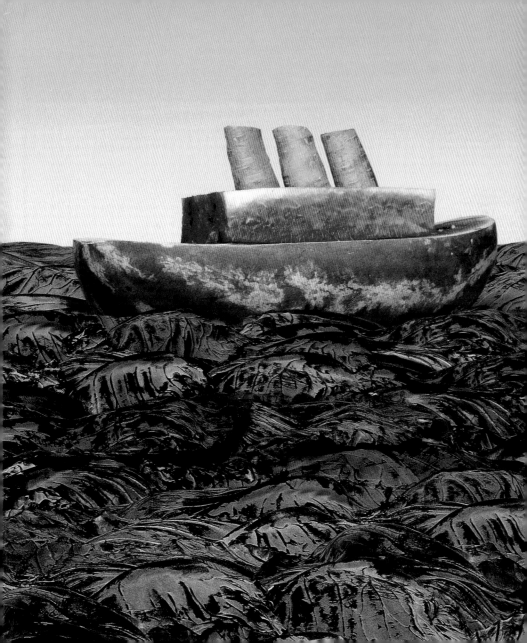

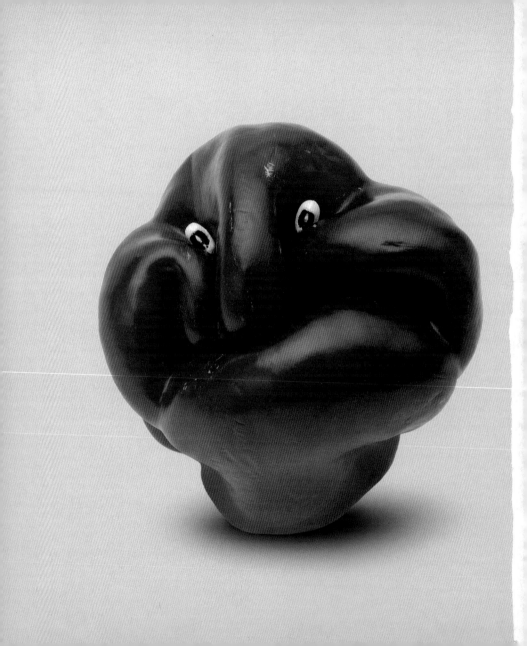

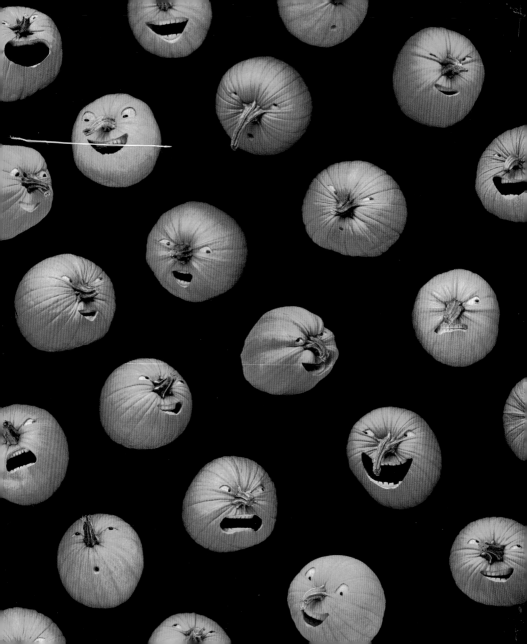